# CY TWOMBLY

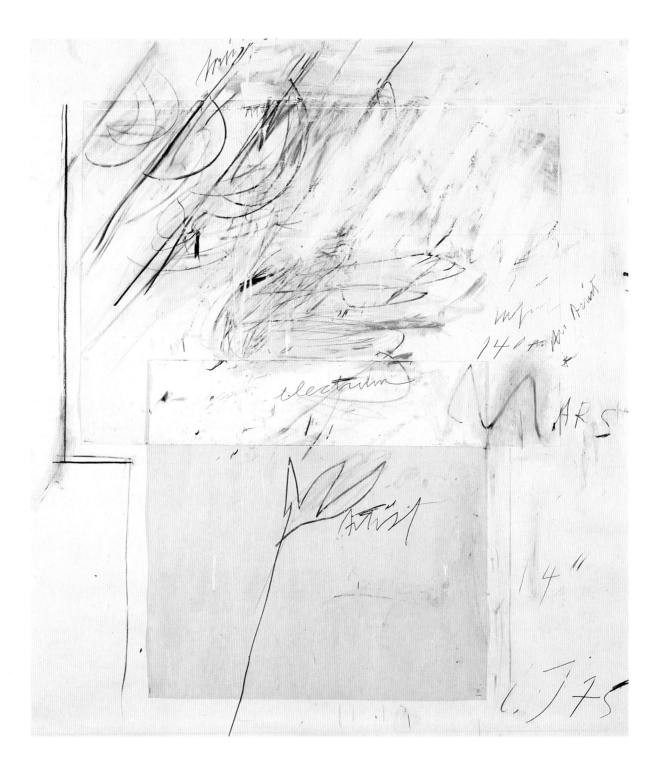

# CY TWOMBLY

Paintings
Works on Paper
Sculpture

Edited by Harald Szeemann
With contributions by Demosthenes Davvetas,
Roberta Smith and Harald Szeemann,
and a foreword by Nicholas Serota

Prestel-Verlag

This book, published by Prestel in an English and a German edition, appeared in conjunction with the exhibition *Cy Twombly: Paintings – Works on Paper – Sculpture* held at Whitechapel Art Gallery, London (25 September – 15 November 1987), and the Städtische Kunsthalle, Düsseldorf (11 December 1987 – 31 January 1988). It is a revised edition of the catalogue, published in German and Spanish editions, that accompanied the Twombly exhibition at its showings in Zurich (18 February – 29 March 1987) and Madrid (22 April – 30 July 1987).

The exhibition was organized by Harald Szeemann.

The publishers wish to acknowledge the generous assistance of Karsten Greve, Cologne, in making possible the English edition of this book.

'Cy Twombly: An Appreciation' translated from the German
by David Britt
'Cy Twombly's "Zographike"' translated from the Modern Greek
by Karen Van Dyck
'The Revolution of the Sign' translated from the French
by Michael Foster
'The Wisdom of Art' translated from the French
by Annette Lavers

Cover illustration: *Untitled,* 1986 (plate 42)
Frontispiece: *Mars and the Artist,* 1975 (plate 29)

Distribution of the hardcover edition in the United Kingdom, Ireland and the Commonwealth (except Canada) by Lund Humphries Publishers Ltd, 16 Pembridge Road, London W11 3HL

Distribution of the hardcover edition in the USA and Canada by te Neues Publishing Company, 15 East 76 Street, New York, N.Y. 10021

Composition, printing and binding: Passavia GmbH, Passau
Colour separations: Repro Karl Dörfel GmbH, Munich
Printed in Germany

ISBN 3-7913-0840-8

# Contents

*Nicholas Serota*  Foreword  *7*

Lenders to the Exhibition  *8*

*Harald Szeemann*  Cy Twombly: An Appreciation  *9*

*Roberta Smith*  The Great Mediator  *13*

*Demosthenes Davvetas*  Cy Twombly's 'Zographike'  *22*

*Frank O'Hara, Pierre Restany, Roland Barthes*  Discussions of Cy Twombly  *25*

Biographical Note  *27*

## Plates

Paintings  *1-42*

Works on Paper  *43-100*

Sculpture  *101-119*

List of Plates  *223*

## *Appendix*

List of Exhibitions  *231*

Selected Bibliography  *237*

Photographic Acknowledgments  *240*

# Foreword

Picasso and Kandinsky in Paris, Beckmann in Amsterdam and New York, Mondrian, Léger and de Kooning, also in New York; exiles working in another culture. Some of the most significant art of the twentieth century has been born in such cross-currents. But the art which emerges is generally the result of an established tradition encountering the new, when accepted patterns are challenged by fresh impulses.

A successful move in the opposite direction, from the new to the old, is rarer and much more difficult to achieve. Twombly is just such a rare example. At precisely the moment when the Abstract Expressionist vein was gaining currency across the world, towing in its wake a generation of younger American artists, Twombly cut himself off. Leaving his contemporaries in New York, he moved to Rome and immersed himself in the grammar and syntax not only of painting, but also of an ancient culture. It was a dramatic, perhaps even desperate move, which resulted in a fundamental reappraisal of the art of painting, conducted in the light of ancient traditions and under a Roman light.

At the time, the decision to leave America must have seemed unwise in terms of career. Now, we can see that it was Twombly's salvation, because he re-established a link with European art and culture that was denied to his peers. Twombly's dialogue is not confined to the ancients. It is also a conversation with the highest achievements of the Renaissance in both art and literature. *School of Athens* and *Night Watch* are just two allusions to the great art of the past and suggest a familiarity with culture which was more common in the nineteenth century than in our own. Indeed, to English eyes, Twombly's range, and his ambition, recall that of another visitor to, if not resident of, Rome – J. M. W. Turner. Like Turner, Twombly's poetry has often been criticized for its opaqueness, but the mood of individual paintings is unmistakable, if not always easily rendered in common prose. Twombly's method involves the creation of a personal language, which may be shared and which gains from bringing together groups of his works.

It is therefore appropriate that this retrospective exhibition should be shown in London soon after the opening of the Clore Gallery at the Tate, where we can now appreciate the richness of Turner's vision. A large-scale Twombly exhibition has long been a wish of the Whitechapel. We have been delighted to collaborate with the Kunsthaus Zurich and, in particular, with Harald Szeemann, who has orchestrated the project. An exhibition of this size could not have been accomplished without the close involvement of the artist. We are grateful to Cy Twombly for allowing us to show several paintings which have not previously left the studio and for his encouragement of the project over several years. We should also like to thank Karsten Greve, who has kindly given advice and support throughout. Generous financial assistance from several institutions and individuals, including City Acre Property Investment Trust, Pauline Karpidas, Janet Green and Charles Saatchi, has enabled the Whitechapel to bring this exhibition to London.

No owner of such fragile works could ever be happy at the idea of their travelling, even under careful supervision. We, and our audience, are indebted to the lenders for their generosity in sharing such works with us.

*Nicholas Serota*
Whitechapel Art Gallery

# Lenders to the Exhibition

Thomas Ammann, Zurich
Öffentliche Kunstsammlung, Kunstmuseum, Basle
Heiner Bastian, Berlin
Albers-Museum, Moderne Galerie, Bottrop
Udo and Anette Brandhorst, Cologne
Nicola Bulgari, New York
Heiner Friedrich, New York
Eva Greve, Cologne
Hannah Sarah Greve, Cologne
Judith Greve, Cologne
Galerie Karsten Greve, Cologne
Gerlinde Greve-Nohl, Cologne
Emily Fisher Landau, New York
Marx Collection, Berlin
The Menil Collection, Houston
Margot Müller, Cologne
Barbara Nüsse, Berlin and Hamburg
Robert Rauschenberg, New York
Nicola del Roscio, Rome
Saatchi Collection, London
Gabriele Stocchi, Rome
Alessandro Twombly, Rome
Cy Twombly, Rome
Tatia Twombly, Rome
Hirshhorn Museum and Sculpture Garden,
Smithsonian Institution, Washington
Kunsthaus Zurich, Graphische Sammlung

and other lenders who wish to remain anonymous

*Harald Szeemann*

# Cy Twombly: An Appreciation

Art historical writing continues to assess art by its mastery and/or freedom of expression, rather thàn by the degree to which this mastery or this freedom is sacrificed to achieve a new freedom – one that knows no fear of tradition because it is absorbed and transmuted, by its own presence in the here-and-now, into a new tradition which becomes a new present. This takes place instantaneously, because when past and present interpenetrate they are not crystallizations of intentions and truths, but constitute a beginning and end in themselves. Such an espousal of freedom may spring from some deep cultural longing; or it may be the journey of the individual sensibility through successive layers of myth; or it may be a constantly renewed encounter between inner nature – always active, saturated with images and destinies – and outer, surrounding nature which, synchronously, becomes a sediment-like deposit in its inner counterpart. This freedom is also a journey through all that is, has been and is still to come, through desires, dreams and intimations, through restful pauses and through restless quests for the sources of imagination and the spirit. It is the collective memory moving amid all those shifting focuses of free association that make up the knowledge of eternal recurrence. These portions of imagination may circulate both slowly and quickly; they may be both prepared and spontaneous.

The individual who is the bearer of such gifts can be educated and childlike, tender and violent, wistful and passionate. His survival is ensured solely by preservation and communication of all the facets of the whole, in all their subtlety and in all those fragmentary traces which present them to others first as riddles and then, increasingly, as beauty. The result is both parable and pictorial idea in one; it is a Glass Bead Game with the universe, a mental labyrinth of spiritual paths, lived out and rendered visible, which does not capture its motions and its pauses by using words, forms or formulae, but leaves them to come and go like the breath of meaning itself. This is the

soliloquy of the great loner, the chosen individual, who feeds on the great cultural longing and uses it to create his works in the here-and-now of the painterly gesture.

No contemporary artist has so succeeded in dematerializing, transubstantiating, spiritualizing the content and expressiveness of line, colour and volume – whether found or imagined – as Cy Twombly has. And this is precisely because the physical plays so great a part in his creative act. Lines of force, acts of force, eruptions of raw psychic energy, like those of the eruptive, Jackson Pollock phase of Abstract Expressionism, are all present in his work – but as a form of withdrawal therapy. They are the seismographic records of a sensibility so totally engaged that it instinctively incorporates a distancing device for its own protection. At first possessing the character of writing rather than script, these eruptions have latterly become waves of paint – controlled as to colour but expansive in movement – rather than self-referential splashes or masses.

Cy Twombly, born in Lexington, Virginia, in 1928, is a contemporary of Robert Rauschenberg and Jasper Johns. Like them, he is heir to the heroic days of America's first indigenous art movement, Abstract Expressionism, and to its fundamental contributions to pictorial creation: total freedom of content and composition; emphasis on the spontaneous gesture, straight from the artist's psyche, both as objective and subjective fact; opening up of pictorial space; and acceptance of the matter of paint as the essence of painting. All this brought with it, almost inevitably, the need for outsize formats. The painter standing in front of a large canvas felt like a pioneer in the desert; the energy of his inner visions was directly converted into the dynamics of pictorial genesis. For all these artists – whether concerned more with gesture, like Pollock and Kline, or with meditation on space and colour, like Rothko and Newman – composition ceased to be a criterion of quality. What was important for all of them – whether they espoused the Active or the

Contemplative Life – was the challenge that confronted the self in the presence of the primal, virtual space of the picture area. They made á *tabula rasa* of centuries of pictorial culture – and also of the elaborate expressive forms which the Surrealists devised to evoke the treasures of the unconscious, whether by giving shape to dream images or through 'psychic automatism'.

Cy Twombly grew up with this freedom. Line is an autonomous, vibrant, expressive entity; paint no longer stands in the service of representation, but is itself the matter and substance of formal creation. And yet even the artist's earliest drawings and paintings betray his individual approach. Twombly handles the new freedoms in his own way: neither combining elements, like Rauschenberg, nor meditatively complicating them, like Jasper Johns, he acts innocently and candidly, without *techne*, without guile. And so a canvas, a sheet of paper, or even an unremarkable everyday object, becomes, with all its inherent spatial, tactile, associative, suggestive qualities, part of a spatial continuum which the innocent artist unveils as the 'landscape of his actions'. The fruits of these actions embody the new freedom from traditional codes and thus constitute a new reality. Point, line and plane are pulverized, fragmented and given a new flux. The iconology of forms and the alphabet of communication are totally undermined. A signature no longer denotes the completion of a work but forms part of the motion which the painting momentarily halts. Twombly's work is a dynamic notation, an epic script, which can only be grasped as a whole, not deciphered piecemeal. (Incidentally, for a long time the drawn elements that intermittently crystallize out of the whole received a disproportionate amount of critical attention; there was much talk of childish scrawls and *pissoir* graffiti. As usual, these partial judgments have a grain of truth in them. Children and those in a state of arousal do automatically see things as a whole before they draw them; but what happens in Twombly's work is that the artist sets out deliberately to stimulate this way of seeing.)

For Twombly, the first thing is the line. It is 'something deliberately artificial and artistic. He has worked on his line, has made it supple enough to convey form, pace, depth and much else besides' (Carlo Huber). The line, which Paul Klee called a path, a guide through the imaginary territory of the picture, becomes, in Twombly's hands, a vibrant, autonomous, complex 'self' and 'other' that roams through wider and wider landscapes, spaces and processes. Or, as Twombly himself says, each line is the present experience of its own inherent history; it explains nothing, but is the event by which it is itself given concrete shape. This more complex, more natural interpretation of line gives rise to a subtler relationship to the picture area, and thus to its space and ground. Twombly distinguishes layers of colour by nuances, reinstating pictorial depth after its neglect by the pioneers of Abstract Expressionism.

Twombly is not alone in this. Parallels from the late 1950s exist in Rauschenberg's 'white' paintings and in those pictorial structures by Jasper Johns which are refined by contact with 'banal and sublime' objects. All have in common the emphasis on white. White as a non-colour, as a suspension of colour, is a symbol of the untouched, of the unknown, of the uncanny and of death; but it is also 'a silence that is not dead but full of possibilities. White sounds like a silence that can suddenly be understood. It is a nothing that is youthful – or, more accurately, a nothing which still awaits its beginning, its birth. Perhaps the earth sounded thus in the white times of the Ice Age' (Kandinsky). Or, as Malevich put it: 'The movement of Suprematism is on the way to a white, objectless nature, to white excitements, to white consciousness and to white purity as the highest degree of every state, that of repose as well as that of motion .... This white nature will be an expansion of the frontiers of our excitement.' This is the sphere of Mallarmé's 'ideal poem, the silent poem all in white'. Twombly seldom uses this evocative symbol, the colour white, in a pure state. As a painter he stands in the direct line of evolution from the Impressionists, for whom an admixture of white meant a light shining through matter, a lightening of the palette.

Twombly is masterly in the placing of his broken layers of white, in which he inscribes his signs and his eventful lines, and from which he simultaneously extracts them. Lines and forms are not set within a white context, as they are with the turn-of-the-century Symbolists, but embedded in the painting and thus bound in all the more intensely with the life of the pictorial space. This space affords them a location in which to deploy their ephemeral, inextinguishable presence. The insertions of white in Twombly's work are symphonic in their nature – think of Whistler's *Symphony in White* – whereas his more conceptual paintings adopt a more neutral ground – a vibrant but impersonal grey. To this he commits his convoluted chalk or crayon lines, with their visible transitions, transposing the act of writing into a physical act. Twombly – and this is the secret of his art – does not take possession of the picture surface; rather, he absorbs it into the place from which he operates – still and vehement, meditative and hyperactive, in a magma of emotions which refuse to be located in time or place – and returns it to the outside world as the pictorial correlative of a moment caught on the wing. The objective and the non-objective, form and formlessness, naivety and

subtlety, faint hint and drastic intervention: all these distinctions are superseded in this art of sublimated empirical experiment and disciplined, orgiastic expansion.

The move to Rome in 1957 did not mark a break: on the contrary, the freedom of pictorial space, already acquired, drew new strength from the Mediterranean environment. The landscape, the light, the presence of Antiquity and the Baroque, the challenge of the Renaissance and Classicism, Leonardo, Raphael and Poussin, became part of a living dialogue, part of the present, in which the artist's own pictorial freedom became entwined with mythical and historical elements. The signs were now more explicit, the grounds more pervasive, more flooded with light. The visual continuum remained; the painterly *élan* became the instrument of narration and thus, in itself, an actualization of myth. Twombly's sensibility acquired a mythic dimension, bringing myth into the present in a way which exemplifies Lévi-Strauss's dictum that 'myth remains myth just so long as it is seen as myth'. In their myths, the men of classical antiquity created a pantheon of incarnate, increasingly concrete, inherited images of gods, demigods and heroes, as well as mortal participants and victims, to represent all the situations of individual and collective life. The mythical material of the birth of Venus from the foam, or of the amorous tussles between Leda and the Swan, Cupid and Psyche, Venus and Mars, is re-created in Twombly's painting through his own expressive resources and the naive, astonished, 'gauche' (Barthes) way in which he approaches the themes (see pls. 20, 32, 66-68). Rome has intensified the process by which Twombly registers, rapidly and concentratedly, the material which forces its way from imagination into consciousness in the guise of memories of a dim mythic past. To conjure and invoke the gods, to link their action and their influence with his own creative process, to give them through his paintings the non-illustrative dimension of entering time and being experienced in all their concentrated power and powerlessness – all this led Twombly in 1961 to an intensification of expressive immediacy. Events and intimations alike now appeared flesh-red and blood-red; paint was smeared and kneaded, rubbed and rolled into balls, squeezed straight from the tube. Concentrations, rather than specific accents or acts of violence, materialized on the canvas; all was fleeting and suggestive, complex and direct, both more and less than symbolic.

Following on the liberation of line and matter, light – long active in Twombly's 'solsticizations' of line, his light-filled 'lunatizations' of the pictorial ground – has become his principal theme in recent years. The signs for sun, clouds and mirrors, for movement and speed, are transformed into a flux of colour, in whose waves the hapless,

lovelorn Leander drowns (pl. 37). They have changed shape, like Proteus; they are metamorphoses in gesture, equivalents for feelings. Although this suggests a move towards the tradition of 'painterly' painting that runs from Turner and Monet to the present, Twombly, as always, evades classification. This is no latter-day 'sea-piece' or 'study of waves', but one great surge of paint, which swells from left to right in green, madder and white, sends aloft its clouds of spray and ebbs away at the right-hand side in tones of broken white. By contrast, Monet's late work at Giverny is governed by 'impressions' arising from daily contact with the constantly changing, magical environment that he had created in his garden: plants, paths, ponds, bridges and, occupying the centre of the stage, waterlilies. Monet's is a joyful, sensuous response to things seen. Closer to Twombly is the late Turner. This is the Turner who flooded the elements with light to the point of representing a disembodied drama of colour. In the tale of Hero and Leander, Twombly breathes into colour his personal vision of the impossibility of contact. In the depths there is peace for one who set out in the heat of the moment, like the wave, to meet his death in the sea.

All the beauty and elegance of the balancing act performed by this prince of painters is present in his sculpture of recent years. Who could forget the five sculptures seen just a year ago, five white objects that seemed to float above their pedestals? They are made from recognizable, used-looking, everyday objects: cartons, crates, cardboard rolls, palm leaves, panpipes. The latest ones consist of sand mixed with plaster, or are directly worked in plasticine and plaster, before being cast in bronze or synthetic resin by a process that destroys the original. All these sculptures are painted with Cementito; the resulting nuances of white, and the intensity of light, rob them of their concrete quality as objects. They transmit an unreal, elusive radiance. They are transmitters of light, transmitters of silence, transmitters of poetry. Looked at closely, they reveal tiny shifts that create interpretative eddies and swirls. Three little pieces of wood, so placed that one is slightly raised, become a wordless, self-contained demonstration of tension, an optical, and no longer a tactile, event. This metamorphosis is immediately evident: with all the *gaucherie* of a naive artist, unspoilt and casual as ever, but including signs of the considerable time spent in meditation upon the objects and their past existence, Twombly bypasses alienation and transports them directly from banality to spirituality. Paint permeates the object, and drains it of all helplessness and absurdity, of its character as a piece of refuse. It enters the category of ennobled objects; it becomes sculpture. In the most recent sculptures (pl. 118) the transitions from one component to

another, or from horizontal to vertical, have been made smoother by pressing malleable material into the joints. The earlier sculptures include 'drawing'; the later ones flow and cascade like the waves of colour in the artist's latest paintings.

No other artist has such a gift for open-endedness. Numbers become dates, words become lines expressive of feeling, lines become tones, tones become tensions, white becomes resolution. All this happens with the flowing naturalness of handwriting, and of play, and in so individual a way that even related forms, such as those of Chinese calligraphy, seem alien. Twombly's script and signs embody a consciousness of time and, especially, of light. Two-dimensional in themselves, they imply further dimensions of experiential space, enmeshed with the artist's own naturally elitist concept of time, which is relaxed enough to leave an expressive statement hanging in mid-air. The resulting wealth of images is nurtured by the whole imaginary museum of imagery and experience within which Twombly operates, not only seeking self-expression but, from a superior vantage-point, dominating the scene that he himself has set. This is so on paper, on canvas, and in the sculptural structures – all of them retain the freshness of speculative invention and yet hold within themselves the seeds of eternity.

This work seems to us both primeval and innovative, like memory itself and its energies. Art at its best is a concentrated essence of life, imagination and dream – and of the audacities, the weaknesses, the fears and the desires of human beings and their gods. Art has its hard-fought battles and wars, its victories and defeats. Its creations are a synthesis of body, soul, heart and *eros,* a record of a momentary state within the evolving reality of an immense sensibility, which seeks to insert itself into the stillness of cultural longing: tender and vehement, conscious, spiritual, boundless.

*Roberta Smith*

# The Great Mediator

'We are making it out of ourselves.' Barnett Newman made this claim for his generation, the first American artists to achieve a truly international status and to significantly affect the course of art. His statement reflects the pride and independence of the Abstract Expressionists, as well as their psychological courage in forging a radical art where before there had been very little. But it also suggests much more.

From the vantage point of the 1980s, Newman's words sound defensive. They appear to pull up the drawbridge against a whole gamut of outside influences, against Europe, against past art, against the surrounding culture in general. This isolationist stance demarcates a territory for art which seems very enclosed, lonely and barren. It posits the artist as a *tabula rasa* with only himself to fall back on. With hindsight, we can also see that while Newman's statement heralded the first great American art, it also foreshadowed the end of something: that line of increasingly pure and insular formalist inquiry which began with Cubism and finished in the rarified hermeticism of Colour Field painting. Hence, words that at first seem exultant can come to sound quite desperate, as if they were the battle cry of a last ditch effort.

Cy Twombly is a member of the generation of American and European artists that emerged in the immediate wake of the Abstract Expressionists and that includes Jasper Johns, Robert Rauschenberg, Andy Warhol, Joseph Beuys, Yves Klein and the somewhat younger Jannis Kounellis. These artists reached maturity in the ten or so years after 1950, and, to a very great extent, they have laid the foundation for the art of the second half of this century. The essence of their contribution was to reignite the issue of referentiality, or subject-matter, in ways that are still of great concern today. They did not deny the Abstract Expressionist notion of selfhood. They made their art out of themselves, but they also made it out of things that existed outside themselves.

Each of these artists brought together in his art some combination of pre-existing materials, images, objects or language – things already charged with extra-personal meaning. All achieved a new, highly referential density in their work which functioned to explicate the larger world while it also explored the nature of art itself. It could be said that Newman's claim to be 'making it out of ourselves' was replaced, or at least supplemented, by Rauschenberg's equally famous statement, that he desired to function 'in the gap between art and life'.

In a sense, it has been Cy Twombly's achievement to function in the 'gap' between these two statements. He has made art out of himself more openly and deeply than Barnett Newman ever imagined possible. By reducing painting to its essence – the mark and its inevitable extension, the line – Twombly found a visual mode capable of registering his most infinitesimal responses, both psychological and physiological. And, as the graphic mark opened his art to the possibility of language and actual writing within painting, he articulated these responses even more specifically. Broaching at times an almost excruciating vulnerability, his oeuvre is an intimate diary of his emotional life that has few equals within twentieth-century art.

At the same time, Twombly has been faithful in his fashion to Rauschenberg's dictum. The other artists of his generation tended to convert aspects of life into art. One thinks of the found objects and images that Rauschenberg brought to his 'combine' paintings; of Johns's careful transformations of generic targets and American flags as well as his casts of such things as a flashlight, a lightbulb, etc.; of Beuys's prolonged involvement with fat and felt as sculpture materials; and of Kounellis's appropriation of both the animate and inanimate – from burlap bags, wood and bedsprings, to animals and even fire – for his installations.

In contrast, Twombly was more inclined to work in the opposite direction, starting out in the realm of the aesthetic and moving towards life. Primary among the 'materials' that he has appropriated are other works of art, whether they are the classical myths set down by the Greek and Roman poets, or paintings from the Renaissance. Even when Twombly's art refers to the landscape,

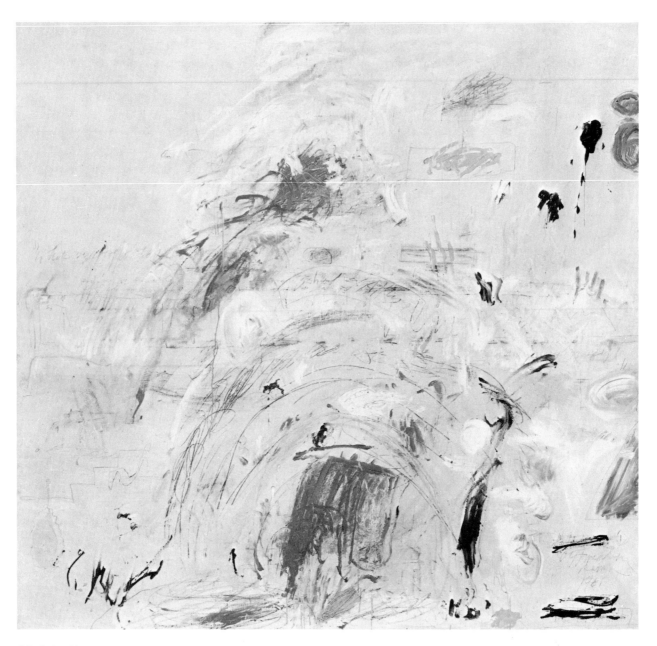

*School of Athens, 1961.*
*Oil, crayon and pencil on canvas, 191 × 200 cm.*
*Private collection.*

as it often does, it is a landscape infused with thought, mythological references, diagrams and poetry and it is, after all, inspired by some of the most assiduously 'cultivated' vistas in the world: those of Italy, where he has made his home since 1957. More important than Twombly's use of the artifacts or atmosphere of culture, however, is the way that his art repeatedly locates that synaptic point where aesthetic experience, rarified and insular as it can sometimes seem, becomes part of real life by virtue of its sheer emotional, implicitly erotic force.

Obviously, this conversion is not entirely a one-directional, art-into-life affair. Twombly leavens his high culture with sturdy doses of the culture of the street. Thus, his highly developed erudition is always balanced by a visceral, even flagrant emotionalism that originates in his touch and in the suggestiveness of his marks.

Confronted with one of Twombly's paintings or drawings, one is always struck by their sense of abandon. Their various combinations of scrawls, graffiti, paint smears, letters, numerals, words, word fragments, diagrams and signs have the visual effect, as I have written before, of seeing 'an overeducated bibliophiliac suddenly – graphically, nearly obscenely – speaking in tongues'. Conversely, it can seem that a primitive or an insane artist has got his hands on one of culture's classics and is telling us what *really* happened, in the most vivid and yet abstract sense. (Twombly's 1961 *Leda and the Swan* [pl. 20] is just one such retelling.)

Few artists have been quite so open about the cultural company they keep. (The obvious exception is James Joyce, and many parallels can be drawn between the two.) A review of Twombly's titles from the late 1950s onwards gives a dazzling reflection of his aesthetic knowledge and affections. The principals, sites and writers of Greek and Roman myth loom large in these titles: Dionysus, Adonis, Orpheus, Venus, Parnassus, Arcadia, Virgil, Sappho. References to less ancient personages are made in works dedicated to Keats, Shelley, Montaigne, Poussin, Valéry, Rilke, Tatlin, Malevitch and Balla. The excited surfaces of the paintings and drawings these titles are attached to tell us how completely these figures live in Twombly's imagination and indicate his determination to make them live for the viewer as well.

Sometimes it seems that Twombly's goal is to show us, in painting after painting, what goes on in an artist's mind, to make visible, and visual, the extensive body of cultural knowledge he carries with him. His work repeatedly gives voice to the voices of other artists, other artworks that haunt and inspire him, that have challenged and sustained him in the course of his career.

Certain of Twombly's efforts seem to be attempts to both honour and exorcise these influences. This is particularly true of the drawings that consist only of names scrawled in big vibrant letters: Virgil, Montaigne, Malevitch, etc. Elsewhere, it seems that Twombly simply wants to reiterate certain beloved masterpieces in his own hand and time. This is certainly the case with two paintings: *School of Athens* from 1961 (ill., p. 14) and *Night Watch* (pl. 21) from 1969. Regarding the first, it is as if Twombly is saying: 'This is what Raphael's masterpiece would look like if it were made today, in the twentieth century, by me, at this point in my life.' The vaulting dome is there, and a hint of the stairs, but all else is different. The dignified stasis of Raphael's strolling and seated figures has been replaced by the perpetual tumult of Twombly's twisting, turning paintstrokes, apparently laid on with both fingers and brushes. Distilling *Night Watch*, Twombly shows us what Rembrandt's painting really comes down to: the yawning gap of the town gate, the cube of space in front of it, the light vibrating off the figures – and all else is black.

In this manner, Twombly repeatedly articulates a highly personal psychology – and physiology – of culture. Making his art out of himself, he also reveals exactly what that self is made of. He shows us more explicitly than is usual that the artist is made of the art that has come before him and that it remains very much alive to him – and within him. Twombly carries within himself a body of cultural knowledge that his own body – culminating in the gestures of his arms, hands and fingers – makes manifest in his art.

In all this, Twombly is more mediator than innovator, more conduit than iconoclast, and he occupies a rather singular position within the history of the avant-garde. Many aspects of his sensibility might even be termed 'pre-avant-garde'. Generally, his art presupposes an unbroken continuity of culture and of aesthetic experience (and pleasure) in which the past is perpetually available to the present. Specifically, he often assumes the stance of the classically trained artist of the academy. He makes paintings 'after' certain masterpieces or in homage to certain masters; he continually recycles classical myth and verse through his art. Yet Twombly accomplishes all this through a series of reductions and conversions that give both his pictorial means and his emotional expression a new extremeness. His art lays bare the transformative processes between culture and self, past and present, literature and painting with a radical clarity, a directness that is avant-garde in character.

Furthermore, within the context of twentieth-century art, Twombly has either advanced or mediated between an amazing array of modernist styles, both mainstream and marginal, which he has fused into his own. Because of his extensive use of literary subjects, Twombly could

be seen as a late, or perhaps the final, Symbolist. The out-of-control quality of his drawing techniques, which are rife with intimations of the deepest unconscious, make his seem like the most sustained automatist career, bringing to fruition effects only hinted at by Miró and the Surrealists. In terms of sheer vehemence, many of Twombly's surfaces have a ragged Expressionist edge as well as affinities to Art Brut, while their decorative beauty can connect them with the flourishes of Tachisme. Finally, Twombly may be the truest of all the 'action painters', as the Abstract Expressionists were sometimes called. Throughout his career, he has conceived of canvas or paper as – to use Harold Rosenberg's famous phrase – 'an arena in which to act' in a completely direct and unpremeditated manner.

The bedrock of Twombly's style remains Abstract Expressionism. Compared to Johns and Rauschenberg, he did not reject the ways of the preceding generation. More inclined to subvert from within, he worked inside its boundaries more completely, yet more originally, than any other artist who emerged in New York in the 1950s. Although he was never grouped with the highly touted, but ultimately disappointing, 'second generation' of Abstract Expressionists, he is arguably the only artist worthy of the name, being the only one whose work is equal to the achievement of the first generation.

Twombly's approach to Abstract Expressionism was deliberately anti-heroic. He deflated its bombast, scaled down its gestures and brought its inherently graphic character to the fore. In the earliest painting included here, a small, dark, untitled canvas from 1952 (pl. 1), we see him operating in the vicinity of Franz Kline and Willem de Kooning with some nervousness and perhaps a little confusion, rather like David among the Goliaths. His two-tiered method of painting is apparent, probably inspired by de Kooning's white-on-black paintings of a few years earlier. Twombly works across a field of solid black with a brush loaded with cream-coloured paint. The upward, rightward drift of his marks, so prevalent in most of his later work, is also visible, but the lines accumulate into a thick, tangled mass and the thought is lost in the material.

Soon, however, Twombly was playing down his use of the paintbrush in favour of tools more precisely suited to his sensibility. After brushing on a monochrome field of white, cream or grey paint, he would switch to graphite or crayon – harder, more pointed tools that functioned much more as extensions of his own fingers. He would then work across the field of paint, which was sometimes wet and sometimes dry, approaching the canvas as if it were a large drawing.

The importance of the shift to graphite and crayon is visible in the several untitled paintings included here which date from 1954, 1955 and 1955–56 (pls. 2, 6-8), especially when seen in the company of the 1952 black painting (pl. 1): it is as if some essential piece of electrical wiring has been hooked up. Suddenly, all Twombly's circuits, from heart to brain to hand to the surface of his work, were connected and put in full working order. He made an irreversible connection to line, which would become the mainstay of his art and so, with very little preliminary trial and error, Twombly became immediately and completely himself.

The electrical metaphor used above is especially apt for an artist whose own inner 'current' or nervous energy is, before and after all its other aspects, so central to the impact of his art. Twombly's line is indelibly his and instantly recognizable; it is more like handwriting than a typical painting touch. It has a certain quaver or vibration to it which keeps the surfaces of his art in a subtle – or sometimes not so subtle – perpetual motion, and this visual motion, accumulating from line and variations on line, gives his work its strong, really irresistible emotional undertow.

The consistency of Twombly's line has also freed him to investigate line's complete malleability, enabling him to assume different artistic guises while still remaining himself and to go to the various extremes which are so much a part of his sensibility. Thus, through the perpetual motion of line, Twombly has kept his development in perpetual motion, moving through a series of very different, but connected, phases in an ongoing investigation of line's fertile possibilities, both expressive and informational.

In the second half of the 1950s, Twombly rapidly sketched in the perimeters of his art, to be amplified and expanded upon in subsequent decades. At times, his progress during these years seems to parallel the growth of the mind itself as it comes to comprehend order, language and sequential thought.

In a large canvas from 1954 (pl. 2), Twombly still 'paints' with line, defining and then filling in a disorderly crowd of flattened, nearly continuous shapes. These suggest creature-like presences, without ever coming into focus, and are slightly reminiscent of Dubuffet. In two small canvases dated 1955 and 1955–56 (pls. 7, 8), he tries out a more classical approach, using a continuous circling gesture to build up spiralling thatches of line in the surface of cream-coloured paint. And in *Panorama* of 1955 (pl. 4), the thatches have been pulled apart; repeating, but separate, gestures spread short, skitterish lines in white crayon across a black ground, suggesting a loose, slanting grid. From the secure vantage point of *Panorama,* which may be the masterpiece of Twombly's early years, the artist makes respectful reference to Jackson Pollock's seminal

drip paintings, although the thin nonchalance with which he animates this enormous surface has a mildly parodistic edge.

The cursive-like fragments drifting in and out of focus on the black ground of *Panorama* make one long for linguistic sense. Not surprisingly, letters and words soon begin to rise to the surface of Twombly's art, spelling out, in their immanent legibility, stronger, clearer emotions. Twombly's progress is traced here in such works as *Free Wheeler* of 1955 (pl. 5), *Sunset* of 1957 (pl. 10) and *Arcadia* of 1957–58 (pl. 11), whose ecstatic surfaces and leaping lines, letters and nascent symbols seem to declaim the endless possibilities of meaning now open to the artist.

It may be clear by now that three basic components have been present in different combinations and ratios throughout most of Twombly's long career. This trio of elements can be given several sets of names. By one definition, according to medium, they can be called language, drawing and painting, or, in adjectival terms, the linguistic, the graphic and the painterly. A more metaphorical designation might be the poetic, the personal and the natural, terms that reflect the way the artist's own febrile touch mediates between culture and nature in his art, with the result that his surfaces tend to oscillate between the most musical of verse and the suggestion of landscape, frequently encompassing both at once. But the most basic and resonant designations for the trio are simply word, mark and material – especially appropriate because the last category includes both the oil paint of Twombly's canvases and the components of his sculpture.

The more than thirty years of Twombly's development have seen a continuous rearrangement of these elements – word, mark and material. Certain series of paintings or drawings seem to advocate their complete integration. Such works aim, it seems, to make painting as intimate as drawing and drawing as full-blown as painting, while making both as legible and meaningful as language itself. Other series seem predicated on the temporary isolation of these elements, allowing Twombly to cleanse and reconcentrate his art. Thus, since the early 1950s, Twombly's art has proceeded via a series of big rhythmic swings in which the complexity builds and then subsides and the different elements have their say. And while, with each swing, the emotional import and subject-matter of his art has shifted, its fervent tone has rarely altered.

As has already been suggested, in the 1950s Twombly concentrated rather exclusively on the relationship between mark and word – that is, between drawing and language. Material – paint – functioned rather neutrally, serving primarily as ground for graphic events or, when laid over these, as a form of erasure and tantalizing mysti-

fication. Colour was all but absent; white predominated, sometimes blending with the canvas almost to the point of invisibility. (Among the few exceptions to the general whiteness of Twombly's surfaces is a little-known series of small, but ferociously scribbled and coloured crayon drawings from 1954 that are included here [pls. 44-46]; they presage with startling accuracy Twombly's crayon drawings of the early 1980s.)

In 1959 and 1960, in particular, Twombly pushes the mark towards the word until an extensive vocabulary of signs, numerals, diagrams and occasional words and phrases emerges. None the less, at this point his interest seems to be not so much in whole words as in marks and signs that are vividly and often polymorphously suggestive, that make words pop into our heads almost before we know it.

To cite one simple example, consider the rapidly made vertical marks along the bottom edge of an untitled work done in Rome in 1959 (pl. 12). They appear on either side of the word 'Bolsena', a town north of Rome that Twombly often visited during this period. These marks could indicate blades of grass or, equally credible, some method of counting or keeping track, such as marking off the days. They are also dotless exclamation marks, signals of an intense but unspecified emotion, whether joy or anger.

Other marks on this painting's surface range in reference from the architectural, through landscape and measurement, to the sexual. At lower left, a thin rectangle, rather like a ruler, is labelled '12″' and nearby is written 'etc.' and a question mark. To the far right, a trio of crude semi-circles numbered '1, 2, 3' could signify Roman arches or three of Rome's Seven Hills. Near these, a vertical mark enclosed in a circle is both a highlighted number 1 and a sgrafitto-like sign for the vagina. Equally suggestive is the possible 'butterfly' hovering above the 'grass' at the painting's bottom edge. A heart shape bisected by a vertical shaft, it is even more credible as a sign for male and female genitalia, possibly symbolizing some androgynous airborne Roman deity.

Although it is actually rather sparse, much is encapsulated on this painting's surface and in other paintings and drawings from this period. Some, such as the drawings done in New York and Sperlonga in 1959 (pls. 58, 59), almost amount to lists of possible marks. More and more, Twombly seems to be aware that these differentiated signs, read sequentially, could lead the eye around the surface in a new narrative way. In the drawing *Rape of the Sabines* (pl. 62), it seems that the entire violent event is diagrammed so that we see a map-like aerial view, anatomical close-ups and images of fire and smoke, all at once.

By 1961, in the group of works that might be called the 'red paintings', a violent Dionysian abandon has com-

pletely replaced the relatively calm, arcadian ecstasies of the 1950s. Twombly increases his use of sexual symbols and brings the material and colour of oil paint unequivocally into the picture. Paint no longer functions as mere ground or cover; it gains equality with, and then dominance over, crayon and graphite. In essence, Twombly pushes mark into material. Using the brush, its handle and his own hand, he converts his distinctive mark into an equally distinctive mode of painting, one that embeds sexual symbolism in an immediate, equally flagrant physicality of paint. On these surfaces, the episodes of drawing and painting are alternately sensuous and obscene, celebratory and furious, additive and destructive. Paint obscures drawing, drawing defaces paint and the results are explosive in every way. As for colour, white is joined first by flesh and pink tones, then by oranges, reds and browns, building a palette that evokes the body and all its fluids. Among Twombly's burgeoning signs, little gun-like phalluses alternate with triangular or slit-like signs for the female sex. The heart shape becomes particularly polymorphous, variously signifying the heart, breasts, buttocks or, again, the vagina. Any of these motifs may erupt with additional marks and brushwork, defacements that also suggest a number of bodily functions, both erotic and scatological.

In the 'red painting' owned by Thomas Ammann (pl. 16), Twombly slyly jokes about his own symbols when he writes, and then partly obliterates, 'Cocktail of the Gods'. Elsewhere on the same surface the words 'Hercules' and 'Venus' appear among the signs for male and female. (Twombly's use of brown – particularly excremental here – can remind us that Hercules's twelve labours included the cleaning of the Augean stables.) While Venus and Hercules are not often paired in Roman mythology, it makes sense that Twombly, perhaps wanting to improvise, might associate the most masculine of demigods with the goddess of love. It is even possible that the trio of flesh and yellow paintmarks in the painting's upper left corner, which resemble tipped, reversed L's and are labelled 'Venus', depict the goddess herself. She reclines on her couch (perhaps à deux) and observes the orgiastic proceedings of the painting below. Another goddess, Io, whose name also doubles for the pronoun of the first person singular in Italian, is noted twice on this surface. Thus does Twombly insinuate himself linguistically – as he already has corporeally – into the action, something he will do even more emphatically in the 1975 collages titled *Mars and the Artist* and *Apollo and the Artist* (pls. 29, 30).

It is not surprising that Twombly's bolder deployment of sign and colour should parallel a more particular use of Greek and Roman myth; in fact, the first makes the second possible. Such symbolic and literal signs of passion and appetite seem to be both necessitated and inspired by gods whose own passions and appetites made them all-too human and whose stories were, in Hans-Georg Gadamer's words, 'a first attempt to resolve the enigma of our existence'. As Gadamer and others before him (Freud, for example) have pointed out, the gods embody the essential conflict between flesh and spirit, ensuring them a place in the human imagination long after the religion that they personify had foundered. These imperfect beings – so frequently pushed to extremes by love and joy, rage and jealousy – are well served by the desperate, passionate abandon of Twombly's own extreme gestures.

After the obsessive intensity of the 'red paintings' and others from the early 1960s it might be expected that Twombly would turn to an opposite extreme. This is certainly the case with his next great cycle of work, the 'blackboard paintings' that begin in 1966 with *Night Watch* (pl. 21) and continue into the early 1970s. In this series, Twombly liberates the mark from the dictates of material – and, for the most part, of the word – and focuses on its extension into line. The corporeal and narrative excesses of the 'red paintings' are gone, as is their sense of vulcanic catharsis. Carnal knowledge gives way to a more cerebral kind, frenzy yields to a more deliberate lyricism, as Twombly investigates the way line alone can create and measure illusions of movement and of space.

In the 'blackboard paintings', done in chalk on grey and sometimes white grounds, paint is as thin as it ever gets in Twombly's work. The resemblance to blackboards is fitting, for each work is a kind of demonstration or rumination upon some isolated fact of gesture, movement or measurement. These paintings are, in effect, motion studies that diagram the action of air, water or the arm itself. Leonardo is a point of inspiration, as suggested by a 1968 collage (pl. 74) that consists of a reproduction of one of his deluge images plus Twombly's own variations upon it; one suspects that Muybridge and Balla are also important precedents.

Certain paintings isolate a single gesture – one kind of mark – and amplify it *ad infinitum*. Others play off two or three kinds of line against each other. Two untitled paintings dated 1968/71 (pls. 22, 23) combine repeating arcs, verticals and diagonals. In both, a syncopating rhythm of line moves down and across the canvas like a rainstorm or waterfall, a progressively amplified soundwave or, simply, a flurry of calculation. Each kind of line seems to measure and annotate the progress of the others; in addition, various scrawled numerals also count off the radiating movement.

In another work from 1971 (pl. 27) a series of loosely limned 'figure 8s' repeat across a space already measured

by narrowly spaced vertical and diagonal lines. And from 1970 there is a painting, never before reproduced (pl. 23), in which cursive fragments repeat layer upon layer over a surface that may well be Twombly's largest. The skill with which this extremely intimate scribble has been scaled up is astounding; one is almost tempted to step into the 'drawing' as through Alice's Looking Glass. It also reminds us that, in all the 'blackboard paintings', Twombly is circling back, retrieving and developing the pure isolated gestures first manifested in *Panorama* in 1955 (pl. 4).

Many of the 'blackboard paintings' go by fast, with a kind of cinematic flicker, as if seen by strobe light. But, looking longer, it is possible to see that they are carefully built up in thin layers of paint and, often, two or more widths of chalk line. This is particularly clear in another large, previously unknown canvas from 1970 (pl. 24). In it, three horizontal rows of looping cursive scrawl, each larger than the next, move down the canvas and out towards the viewer. Twombly has retraced each row of looped line several times, each time more erratic than the last, so that the lines seem to be unravelling, spiralling out of control before our eyes. Adding to the surface's instability is a faintly visible, earlier layer of *Panorama*-type scribbles. Again, the analogy to soundwaves fits: Twombly's marks echo and reverberate, as if they track the course of a foghorn's deep bass through the night.

The 'blackboard paintings' alternate with shorter series, outstanding among which are the paintings done in Bolsena in 1969 and represented here by two drawings (pls. 72, 73). In them, tumbling squares – suggestive of both doorways and painting surfaces, and frequently bristling with terms of measurement – define a shifting landscape, at once natural and mental. They reiterate the landscape motif implicit in many of the paintings from the late 1950s and early 1960s, but in a grand, confident manner.

Since the mid-1970s, Twombly's production has become increasingly polymorphous, with different series, in different media, seeming to proceed simultaneously. Word, mark and material – language, drawing and painting – have been isolated, integrated and expanded upon in a number of ways. Signs of expansion are everywhere: in the animated efflorescence of continuous paintmarks that characterize certain shapes or entire surfaces; in an increasing use of long phrases or entire poems, whereby Twombly makes various themes and readings unavoidable; and, above all, in the recurring emphasis on paper and an elaboration of collage that has given both the status of painting.

Sometimes these isolations and expansions happen all at once, as when Twombly combines multiple surfaces, some covered with paint, some with text, into a single work of art. In the four-part painting/drawing *Hero and Leander* of 1981/84 (pl. 37), lush abstract brushwork, extending over three large, separate canvases, evokes the prolonged breaking of a wave. Leander's name is written in Italian ('Leandro') across the leftmost canvas, where the soft greens give way to reds and blacks and the wave appears to break most violently – blood upon a rocky shore. The name may symbolize the body (or soul) of Hero's drowned lover, or it may be her last cry as she throws herself from her tower to join him in death. On a fourth surface, a small, framed drawing that leans against the wall, Twombly pinpoints the moment by writing 'He's gone, up bubbles all his amorous breath'. Here, as in much of his recent work, the epic breadth diminishes, and Twombly narrows in on the denouement, an instant of death or a moment of grief and elegaic lament.

Twombly's 1976 three-part drawing *Thyrsis's Lament for Daphnis* also charts a descent into grief. The first drawing is a collage that doubles as title page; beneath the written title, a sheet of translucent graph paper veils a cloud of heavy black marks. The centre drawing is the lament itself, quoted from Theocrites's *Pastoral Poetry*. And in the third drawing, another cloud of heavy dark marks, this time unveiled, seems to obscure a word at the bottom of an otherwise empty page. Thus, over this sequence of drawings, the lament is vocalized and silence descends.

Obviously, Twombly's expansion of collage to include separate surfaces enforces the sequential reading of his art, enabling even his most abstract efforts to achieve a narrative character. In certain works that concentrate exclusively on paint, a kind of descent, or breaking wave, is often depicted. In a three-part painting on paper from 1980 (pl. 34), a dark wave of mostly greens and blacks begins, expands and diminishes over the course of three separately framed drawings – one small, the next very large, the last smaller still. The lower left corner of the big central drawing has been folded back, allowing lighter tones of brown and yellow to escape. The work's subject would appear to be some kind of transition: the approach of a storm, of night or of death. In this meeting between the forces of darkness and light, darkness wins: the final drawing, made with xerox, is a small black rectangle.

A similar passage or wave dominates a less foreboding two-part painting (pl. 35) whose upper vertical canvas is nearly filled by a burgeoning cloud of green. That this phenomenon is much larger than the canvas itself is confirmed by the second canvas – a small oval that hangs just below the first and is covered with the same dark green. It appears to give us a porthole's view of the greenness.

This painting may remind some viewers of Correggio's rendition of Jupiter and Io, which is similarly dominated by a beautiful, tantalizingly abstract, yet clearly inspired cloud of green.

These paintings and other abstract works, such as the 'Gaeta sets' (not included here) – those serial works on paper that Twombly has made in a seaside town near Naples – seem to mark a new phase for the artist. New precedents, Turner and Monet among them, are alluded to. A love of nature, of the sea, of floral life, seems to have superseded that of literature. Never has his painterliness been so total, nor his light so real. Yet these paintings are infused with Twombly's familiar nervous energy; the paint is dappled, marked and poked at, as if he wants to prod an almost linguistic articulation out of sheer matter. Furthermore, in these waves and deluges of paint and brushwork, one cannot help but feel that the linear motion studies put forth in certain 'blackboard paintings' have been fleshed out and given full-bodied expression.

At the same time, Twombly's interest in less pastoral themes and more explicit narrative has continued. His most ambitious use of multiple surfaces came in the late 1970s with his unapologetically epic masterpiece *50 Days at Iliam*. This painting or, more accurately, painting cycle consists of ten often enormous canvases, each depicting a different aspect of the heroic struggle between the Ilians and the Achaeans from Homer's *Iliad*.

On virtually every canvas, Twombly spells out what he has also painted and drawn. The words 'Shield of Achilles' hover above the circular gathering of strokes in the first canvas; in the fifth, 'the fire that consumes all before it' appears beneath the blur of flaming red. Alternately, Twombly gives his writing the weight and movement of image, something he had started to do in such 'name drawings' as *Virgil* and *To Valéry* of 1973 (pls. 82, 83). The canvas entitled *House of Priam* is dominated by the vibrating presence of Cassandra's name, while *Achaeans in Battle* simply lists the tribe, its leader (Achilles), his bravest warriors and the Greek gods on their side in letters that have a life all their own.

In *50 Days at Iliam* Twombly returns to his complex programme of the early 1960s, able at last to give word, mark and material absolutely equal and impassioned emphasis. This balance has continued, on a more intimate scale, into the current decade. It is apparent in the vibrant massings of colour and line, variously floral and electric, that characterize the oil and crayon drawings entitled *Proem* (pl. 94), *Nimphidia* (pls. 91, 92) and *Proteus* (pls. 97, 98) from 1982-84, and is more prominent still in the two paintings entitled *Wilder Shores of Love* from 1985 (pls. 40, 41). These works are neither as sexually polymorphous

(nor as populous) as Twombly's surfaces from the early 1960s. Less orgiastic and more private, they still perpetuate the intensely erotic side of his art.

Last but not least, Twombly's sculpture must not be overlooked, idiosyncratic as it may sometimes appear. After making less than ten of the white-painted wood constructions in the second half of the 1950s, the artist suspended sculptural activity throughout the 1960s and early 1970s. Since taking up sculpture again in 1976, he has produced at least thirty works, with several of his more recent pieces being cast in bronze and then painted white. It is fitting, in a period when Twombly's paintings and drawings have used multiple and appended surfaces so extensively, that he should also piece together a greater number of sculptures.

Twombly's sculptures exist outside the real-time and ongoing metamorphosis of his two-dimensional work. They vary, but they do not develop. None the less, they inform, and are informed by, his paintings and drawings, providing a constant distillation of his sensibility, one that is full of keys and signals. These sculptures are usually pieced together from all manner of salvaged scrap (bits and boxes of wood, poles, cardboard cartons, pieces of tin) and joined by equally various methods (string, nails, wire, clay, plaster). Unified by a sparing layer of white, they exemplify, quite literally, Twombly's ability to borrow from a variety of historical and vernacular sources and make these borrowings his own.

Made primarily for his own enjoyment and infused with an unusual tenderness, Twombly's sculptures resemble toys or cherished pieces of junk, as if they had been made by a naive or street artist. In this way they offer us the three-dimensional equivalent of the artist's sgrafitto. But they are also the work of an unusually egalitarian aesthete, an artist who can see poetic and imagistic possibilities in all sorts of unlikely things.

One sculpture from 1959 (pl. 102) suggests, among other things, Pan's pipe; one from 1978 (pl. 107) – a horizontal linear structure with little wheels at one end – suggests an attenuated, nearly abstract charioteer and chariot. A number of compact, boxy sculptures evoke mausoleums, sarcophagi or little altars, complete with offerings to the gods. Several others look like little boats. A group of elegantly vertical works, all from 1983, alternately evoke figures or trees or, in one case, a kind of primitive hoist (pl. 112). But no matter what form they take, each of Twombly's hand-wrought sculptures is a kind of memorial – white-shrouded, tenuous and elegaic.

In their ancientness of surface and association, Twombly's sculptures isolate his love of the past with unusual purity. They bring out the Egyptian in him, the artist

who deals only with those themes and motifs that have been passed down, retold and repainted again and again, their meanings guaranteed, available to all. Yet, in their vulnerability of scale, structure and emotional tone, these pieces also convey a hypersensitivity that is unequivocally internal, and so they repeatedly pinpoint the intersection of cultural and personal experience. Like all his work, they confirm Twombly as an artist who has consistently bared his heart, his mind and his soul in the making of his art, using the art of the past to reveal once more the age-old passions and fears that regularly seize hold of him – and us. In a way that is extremely intimate and implicitly modern, Twombly's art asks those deeply private, nearly unspoken questions that lie at the core of all human activity: whom shall I love, how will I die, how and by whom will I be remembered?

# Cy Twombly's 'Zographike'

The Greek word for painting, *zographike,* is a compound of the words *graphike* ('writing') and *zoon* ('living being'). If we take the view that this word means (for the Greeks at least) nothing more than the art of writing down life, while not forgetting that the word *graphike* also entails a willingness and, more importantly, a desire on the part of Being to inscribe, to sketch what is most impressive or surprising in life (that which *is,* that which *exists* in everything, which in turn *exists* in infinity), then it follows that the work of the American artist Cy Twombly is comparable to this desire of writing to intervene between the seen and the unseen and to become the subject.

The 'writing-subject' of this particular artist, who was born in Lexington, Virginia, but who has been based in Rome since 1957, can be extremely subversive, while all the time giving off an air of childish freedom and fantasy: it becomes the school child's unruly behaviour in the face of an authoritative teacher (here, of course, we are anthropomorphizing a cultural system). In the hands of this school child the 'writing-subject' – the final destination of a process that begins in the eye, turns into thought and then travels from one end of the body to the other until it reaches the fingers or the palm – disclaims the already existing, visible and historically meaningful order of the alphabet as taught in the school books (again, we are up against cultural history). This denial is not some secret disobedience, like a pupil's scribbling in the margins of an exercise book during lessons; rather, it is part of a conscious decision to move away from the margins into the centre of the page, to take over the page completely.

It is a 'writing-subject' which contains not only an element of entertainment and enjoyment, but also of desire – the desire that the letter in the alphabet should lose its established shape and become a line, a line which can transform itself into a drawing, figure, geometric diagram or musical note, a line which carries in its own body a symbolic function: the transformation of the already known, the rewriting of the already known. It is a line which is form, a form which refuses to be defined by fixed characteristics, a form which does not wish to be led around by the hand, since, just as it is about to close, it opens again. It is thus in a state of constant flux, a permanently open system, in which the place of each element in pictorial space is dictated by the logic of necessity. It resembles a dance by two dancers whose improvised movements can easily take unexpected turns, as their passion demands that they constantly invent new steps or movements.

This 'writing-subject', this line which does not seek to destroy the painting's surface or to destroy the already existing material of history but, instead, wishes to disperse it to areas it has never occupied before, brings with it a strategic manoeuvre: the journey by which 'writing' can become language.

This language is not an act of mimesis of external reality; it does not seek to reconstruct from memory precise pictures of everyday life. On the contrary, it is an act that breaks through existing visible reality, becoming the instrument of a search for the deepest secrets of another reality. This language itself becomes a reality in whose body the greatest power is granted, not to re-presentation, but to presentation.

This language is an act of 'offering'. It returns to the very birth of culture, takes culture as its material and, after studying it (that is to say, after living through it in thought, aesthetics and body), offers it back to the ever-open book of cultural history. In short, it is a language which unites thought and praxis. It is the place where thought and praxis co-exist, a place which offers material for dialogue. It is a language whose very composition contains the seed of motion. It is a language which is the embodiment of motion, the song of a personal, eclectic collection of particular cultural moments – so personal, that the 'I' becomes transparent and the song consequently takes on collective dimensions. It is motion itself in all its varied transformations, in its life of constant vigilance. It is motion itself in the way that it presents itself as a continually developing alphabet or in the

way that it responds to questions such as 'What is it?' – 'How is it?' – 'Who is it?' with the same straightforward reply: 'It is'. Our mind cannot but have recourse to the visual presentation of the verb itself, to the inexhaustible power of Proteus, to every idea of fluidity, to Heraclitus's river – in other words, to 'energy' and 'metamorphosis'.

These two terms reinforce each other in the work of Cy Twombly: the second needs the first in order to realize itself, but the first also needs the second in order to avoid chaos, in order to avoid formlessness (something which the artist seeks to avoid at all costs). The first needs the second in order to take on a shape; a shape, however, which resembles the varied roles of an actor or a childish game of make-believe on the beach on a summer day. The small tower or the battlefield made in the sand by a group of children is destroyed a few moments later by the unforeseen step of a pedestrian, by the weight of a wave or by the wish of its makers. It becomes something else, yet the material – the sand – remains the same, always pliable and strong, but ready to change shape, and always ready to be used as a symbol of passage from the negative to the positive, from the solid to the liquid, from the one to the other, from this to that and vice versa.

This is also true of Cy Twombly's 'writing-language': there is no product that does not bear the sign of its transformation, of its passage from the static to the moving, from the inexperienceable to the tangible, from the shapeless to the shaped (ready to change at any moment). With every work of this artist, be it sculpture, painting or drawing, the 'writing-language' testifies that the work is an open-ended organism, whether by reference to words or phrases (for example, the name Proteus), by the inclusion of elements inherently symbolic of transformation (the rose, for instance) or by the very line that has constructed these elements. In order to possess this constant transformative ability, the 'writing-language' continually needs to 'appropriate'. 'Writing' appropriates everything that attracts its attention, that surprises it, that provokes its curiosity over some mystery. By being such a good sponge, such a high-quality filter, it is ultimately able to offer the product of this experience, this research, to 'language', which can thus continue its wandering in pictorial space. This wandering does not, of course, have a purpose (*telos*) in the sense in which Aristotle uses it in his definition of tragedy. It is not intent on enforcing a moral (or ethical) lesson (not, at least, in the everyday meaning of the word 'ethic'); on the contrary, it is a 'writing-language' which, instead of using its material for some purpose, subjects the purpose itself to pictorial space, thus making a display of the world or of our desire for the world. In other words, it is the moment of break-ing away from the senses, the moment of cultural ritual, one more page in the drama (not the tragedy) by that unknown playwright who once began the theatrical work 'The History of Culture' which, to this day, remains unfinished.

### The Picture in Cy Twombly

The picture in the work of Cy Twombly is never closed, never a predetermined narrative which aims at creating an easy, cheap psychology: it is the embodiment of its own transformation, of its own motion. The picture does not simply present the viewer with the representation of a real-life drama, but instead presents the traces of this drama, whatever is left over from it – pliable shadows which, at the same moment, are the eternal forces of that drama. The picture in Cy Twombly is neither a didactic nor an explicit statement. It is the space where the event takes place, it is whatever remains from an event, it is exactly those left-over fragments which certify that the event has taken place, that it incontrovertibly took up space. After the action, these fragments cannot, however, be used as the stuff of nostalgia or worship (as in an archival, museum-like presentation of the past) but, on the contrary, they become the starting point for a new way of using the material, a new way of reworking it. In this way the picture inevitably turns into its own kind of reality, the reality of a permanently open macrocosmic structure constructed from its own basic elements – that is to say, from its abundant microcosms. In short, it becomes the mirror of Laocoonian intricacies, of all those antinomies (of the seen and the unseen) which make up the world.

The picture in the work of Cy Twombly is not the result of a gesture of content (of hypothesis), not the bearer of some message. Instead, it is the space where the gesture gathers together its energy – and with such passion that it is able to transcend the limits of art history and reach the plane of cultural history. Ultimately, the picture becomes the gesture. This means we have a picture-gesture which has no ambition to illustrate history. Instead, it simply takes history as the space where it can act out its energy, like material in the midst of a transformation. Consequently, this picture-gesture cannot be viewed merely as a movement of the hand (an external factor) but must also be seen as a kind of behaviour – like that of a child who, after discovering that he cannot change the world, decides that he can at least draw it. From the moment it appears on the surface of the painting, this image of the world bears traces of that change which the 'child' was unable to effect: the world appears as his desires would like it to be.

*The Child in Cy Twombly*

This child is present throughout Cy Twombly's work: not as a realistic representation of children or adolescents, but as the organic bond between the artist and his working material. The child is the impatient way Cy Twombly treats his paintings, his fantasy and freedom of gesture. It is his thirst for appropriation – shock – curiosity – fear – satisfaction – tenderness – innocence – precision – playfulness which characterizes the lines of his 'writing'.

The 'child' in the 'language' of Cy Twombly is something more than reluctance, more than a fear of adjusting to the environment, more than a refusal to become grown-up. It is a symbol of liveliness, logical and illogical, spontaneous and intuitive; it is the power of flexibility and elasticity, the groundwork, anthropological material, that kind of primordial material which can be completely transformed. It is the denial of geography and of a pre-determined realism; it is the space where the most heterogeneous elements coexist, thereby creating a kind of mysterious allure.

So the child in the work of Cy Twombly is a kind of behaviour. It is a magical action which creates a ritualistic bond with the beholder – the last person to stand in front of the artist's concentrated effort, in front of the immediacy of colours and lines and their rhythm, in front of the drunken sway of letters and words, in front of the intoxication and the music which gives rise to the material's organization in pictorial space. The viewer has no choice but to enter into this atmosphere, to become a part of the body which is wandering (the artist's 'language'), to interpret as he wishes the fragments which meet his eye, until he reaches the point where he actually rearranges them as he likes, as his dreams, intimations and desires suggest.

The work of Cy Twombly adumbrates the spirit of our times, in which art is intent on invoking subjectivity, myths, the power of expressive painting, the possibilities of the 'fantastic' and, still more important, the participation of an erotic element and the combination of mind and body in creation. Yet in contrast to the many painters today who like to eulogize the past, Cy Twombly is not interested in the tiresome repetition of well-trodden paths. He wants to go further: his work is an act that touches the depths of the collective unconscious. It is a positive act, an act whose conception and composition hides a particular function: the desire to transform. It is a tool that makes the unseen seen.

Imagine yourselves one sunny afternoon out for a walk; you come upon an ancient tower with great gardens and lakes surrounding it or, even better, upon an ancient city filled with precious relics. Towards the end of your walk, winding through the streets just before the sun sets, you suddenly have the impression that all that you have seen was not really old, was not really dead. Instead, with the power of your imagination you can transform it into another form of the 'old': the new. It can become another episode in the book of the history of wandering. If you were to do this, you would certainly feel the joy of the beauty, that calm beauty, from which the works of Cy Twombly emerge. And then, perhaps, you might hear, like a soft lullaby, the tender confession expressed in the lines of the poet C. P. Cavafy:

I sit and dream.    Desires and sensations
I brought to art –    things partially glimpsed,
faces or lines;    of unfulfilled love affairs
certain indistinct memories.    Let me submit to art.
Art knows how to arrange    Beauty's Form ...

*Frank O'Hara, Pierre Restany, Roland Barthes*

# Discussions of Cy Twombly

## The Painting is the Form

His new paintings are drawn, scratched and crayoned over and under the surface with as much attention to aesthetic tremors as to artistic excitement. Though they are all white with black and grey scoring, the range is far from a whisper, and this new development makes the painting itself the form. A bird seems to have passed through the impasto with cream-coloured screams and bitter claw-marks. His admirably esoteric information, every wash or line struggling for survival, particularizes the sentiment. If drawing is as vital to painting as colour, Twombly has an ever-ready resource for his remarkable feelings.

*Frank O'Hara,* New York, 1955
(From the catalogue of the one-man show held at Galleria La Tartaruga, Rome, in 1963.)

## The Revolution of the Sign

Twombly occupies a unique position at the centre of the young generation of American artists. He is a lone wolf who left New York to settle in Rome, a person apart, a 'character'. His graphic language is poetry and reporting, furtive gesture and *écriture automatique,* sexual catharsis and both affirmation and negation of the self. As full of ambiguity as life itself, it appears on corners of walls, in schoolyards and on the fronts of monuments. Twombly's 'writing' – and this is the miracle – has neither syntax nor logic, but quivers with life, its murmuring penetrating to the very depths of things. The marks are allusive since they instinctively make for the essential. This figuration, which breaks through white emptiness with all kinds of potential meanings, is rich in intention and content. The synthetic notations give rise to an overall atmosphere very close to what is known as a 'poetic world'. Yet we

are not concerned with literature in the strict sense of the term, for there is colour, formal intensity and movements of the hand.

The latest works by Twombly, which I saw in the summer in Rome, emphasize the directly expressionist nature of this language. The artist has progressed a stage further along the road of communication. Oil paint – applied in handfuls, rubbed, squashed, scratched, wiped and dripped – hurls its tones at, and distributes its blots, patches and chaotic configurations across, the bare canvas; vibrations, both gentle and shrill, are applied to the rough impasto. Twombly has gone a step further in the affirmation of his expressive power. This is a far cry from the false naivety of the scribbles that Dubuffet inscribes carefully into his impasto – and a far cry from the baroque heterogeneity of Rauschenberg's or Larry Rivers's 'writing'. The graphic language of Twombly remains at all times inimitable. This is undoubtedly because, in the final analysis, he owes nothing to anybody. He makes use of all the common areas of current symbolism, but at the exact moment when their significance becomes exhausted – that is, when the cross is no longer a cross, when a number is more itself than part of a numerical sequence, or when an erect phallus expresses the desire of the entire world by being subjected to depersonalizing schematization. The miracle of Twombly is precisely this manner of *writing,* of dis-figuring symbols, alphabets and numbers; and of expressing nothing but himself, with a claim of absolute totality, when he accomplishes this *revolution of the sign.* Expressing nothing but himself, totally – that is the fluctuating rhythm, contradictory, secret and esoteric, of the creative act. Twombly's egocentric sincerity is the sun radiating from his work.

*Pierre Restany,* Paris, 7 September 1961
(Translated from the catalogue of the one-man show held at Galerie J, Paris, in 1961.)

We must count as surprises all the interventions of writing in the field of the canvas: any time Twombly uses a graphic sign, there is a jolt, an unsettling of the natural-ness of painting. Such interventions are of three kinds (as we shall say for simplicity's sake). First there are the marks of measurement, the figures, the tiny algorithms, all the things which produce a contradiction between the sovereign uselessness of painting and the utilitarian signs of computing. Then there are paintings where the only event is a handwritten word. Finally, there occurs in both types of intervention a constant 'clumsiness' of the hand. With Twombly, the letter is the very opposite of an orna-mental or printed letter; it is drawn, it seems, without care; and yet it is not really childlike, for the child tries diligently, presses hard on the paper, rounds off the cor-ners, puts out his tongue in his efforts. He works hard in order to catch up with the code of adults, whereas Twom-bly gets away from it. He spaces things out, he lets them trail behind; it looks as if his hand were levitating, the word looks as if it had been written with the fingertips, not out of disgust or boredom, but in virtue of a fancy which disappoints what is expected from the 'fine hand' of a painter. This term was used in the seventeenth century to describe copyists who had fine handwriting. And who could write better than a painter?

This 'clumsiness' of the writing (which is, however, inimitable: try to imitate it) certainly has a plastic function in Twombly. But here, where we are not speaking about him in the language of art criticism, we shall stress its critical function. By means of his use of written elements Twombly almost always introduces a contradiction into his painting; 'sparseness', 'clumsiness', 'awkwardness', added to 'rareness', act as forces which quash the ten-dency, found in classical culture, to turn Antiquity into a depository of decorative forms; the Apollonian purity of the reference to Greece, felt in the luminosity of the painting, and the dawnlike peace of its spaciousness are 'shaken' (since this is the word used about *satori*) by the repulsive use of written elements. It is as if the painting were conducting a fight against culture, jettisoning its magniloquent discourse and retaining only the beauty. It has been said that the art of Twombly, unlike that of Paul Klee, contains no aggression. This is true if we conceive of aggression in the Western way, as the excited expression of a constrained body which explodes. Twombly's art is an art of the jolt more than an art of violence, and it often happens that a jolt is more subversive than violence: such, precisely, is the lesson of some Eastern modes of behaviour and thought.

....

There are paintings which are excited, possessive, dog-matic; they impose a product, they turn it into a tyrannical fetish. Twombly's art – and this constitutes its ethic and its great historical singularity – *does not grasp at anything*; it is situated, it floats and drifts between the desire which, in subtle fashion, guides the hand, and politeness, which is the discreet refusal of any captivating ambition. If we wished to locate this ethic, we would have to seek very far, outside painting, outside the West, outside history, at the very limit of meaning, and say, with the Tao Tö King:

> He produces without appropriating anything,
> He acts without expecting anything,
> His work accomplished, he does not get attached to it,
> And since he is not attached to it,
> His work will remain.

*Roland Barthes*
(From the catalogue of the one-man show held at the Whitney Museum of American Art, New York, in 1979.)

## Biographical Note

Cy Twombly was born on 25 April 1928 in Lexington, Virginia. He studied at the Washington and Lee University in Lexington, the Museum School in Boston and the Art Students League in New York, and spent the summer of 1951 at Black Mountain College, North Carolina, where he met Franz Kline, Robert Motherwell and Charles Olsen. In the same year he travelled with Robert Rauschenberg to France, Spain, Morocco and Italy, staying on in Rome until 1952. He then returned to New York. The first exhibitions of his work took place at this time. He has lived in Rome since 1957.

# Paintings

1 Untitled, 1952

*Oil on canvas, 73.5 × 91.5 cm*

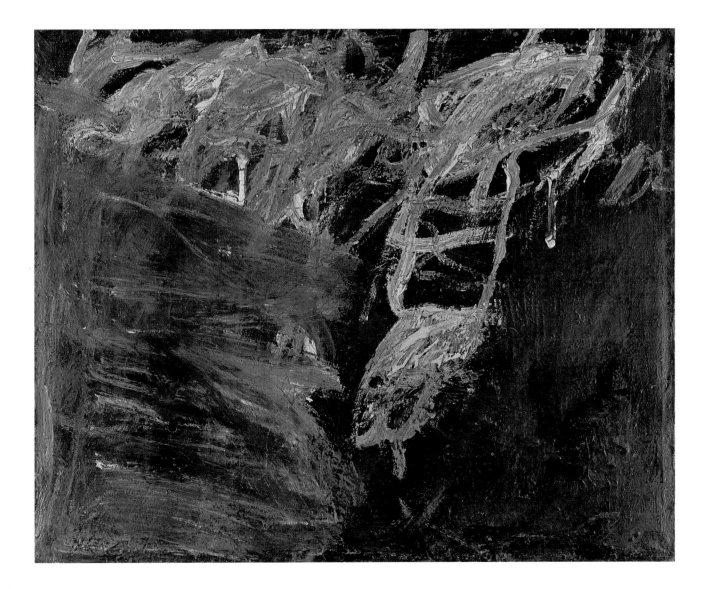

2 Untitled, 1954
*Oil, crayon and pencil on canvas, 174.5 × 218.5 cm*

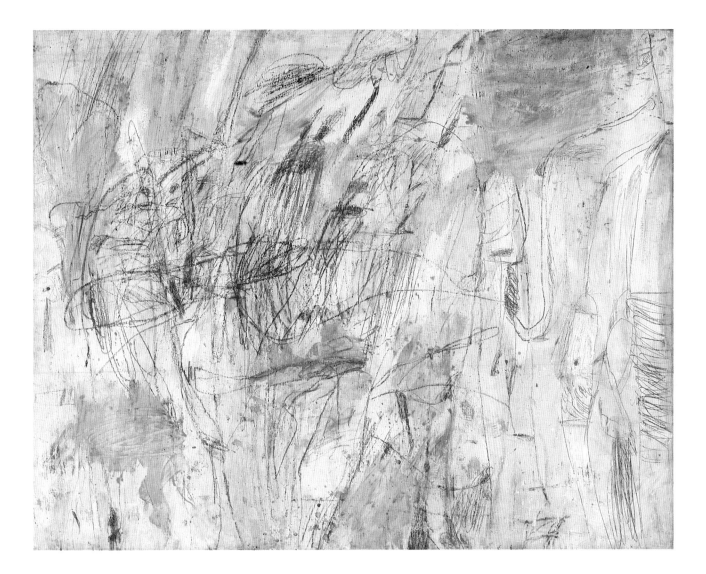

3  Untitled, 1954
*Distemper, crayon and pencil on canvas, 120×72 cm*

4 Panorama, 1955
*Distemper and crayon on canvas, 254×340.5 cm*

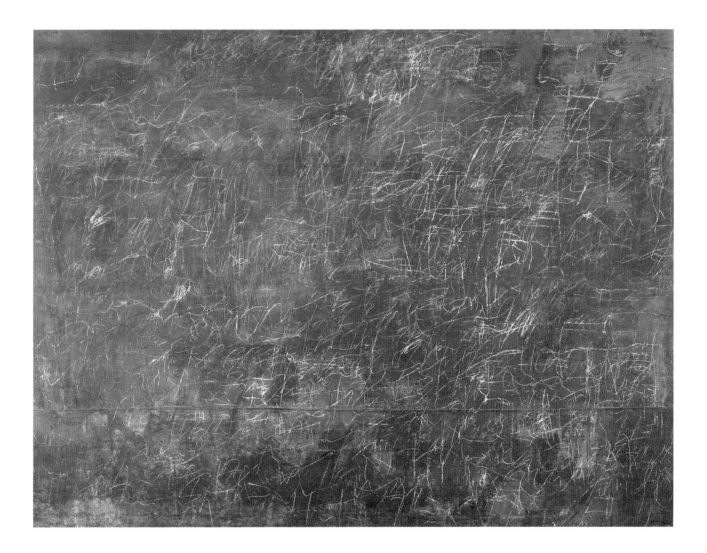

5  Free Wheeler, 1955
*Oil, crayon and pencil on canvas, 174 × 190 cm*

6  Untitled, 1955
*Oil and graphite on canvas, 71 × 122.5 cm*

7  Untitled, 1955/1956
*Oil and graphite on canvas, 114.7 × 135.4 cm*

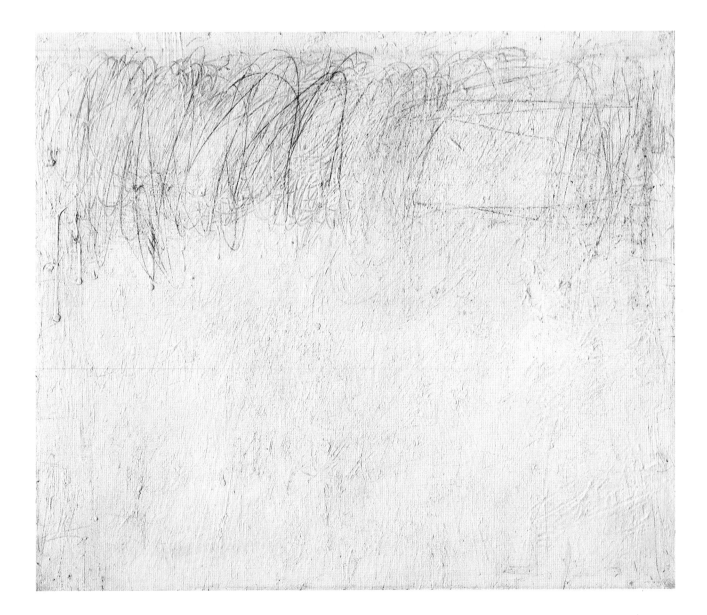

8  Untitled, 1955/1956
*Oil and graphite on canvas, 114.7 × 135.4 cm*

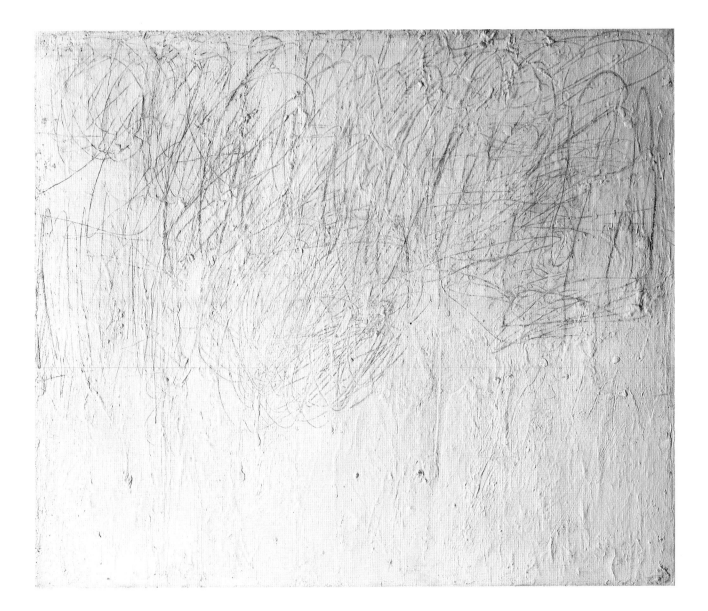

9  Untitled, 1957
*Oil, crayon and pencil on canvas, 174 × 191.4 cm*

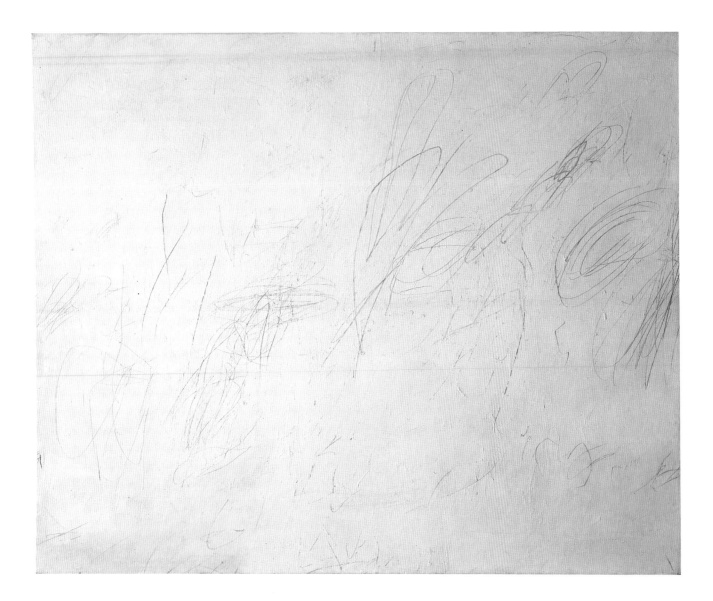

10 Sunset, 1957

*Oil, crayon and pencil on canvas, 142.5 × 194 cm*

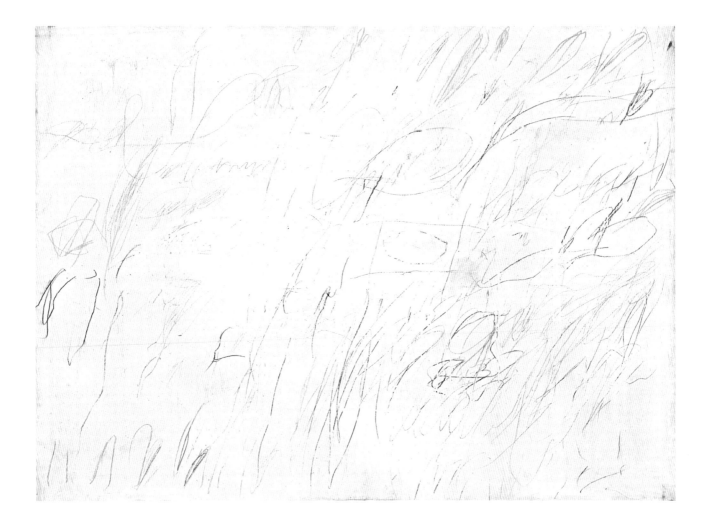

11  Arcadia, 1957/1958
*Oil, crayon and pencil on canvas, 183×200 cm*

12  Untitled, 1959
*Oil, crayon and pencil on canvas, 147.7 × 242 cm*

13 Untitled, 1961
*Oil and crayon on canvas, 130 × 150 cm*

14  Triumph of Galatea, 1961
*Oil, crayon and pencil on canvas, 294.3 × 483.5 cm*

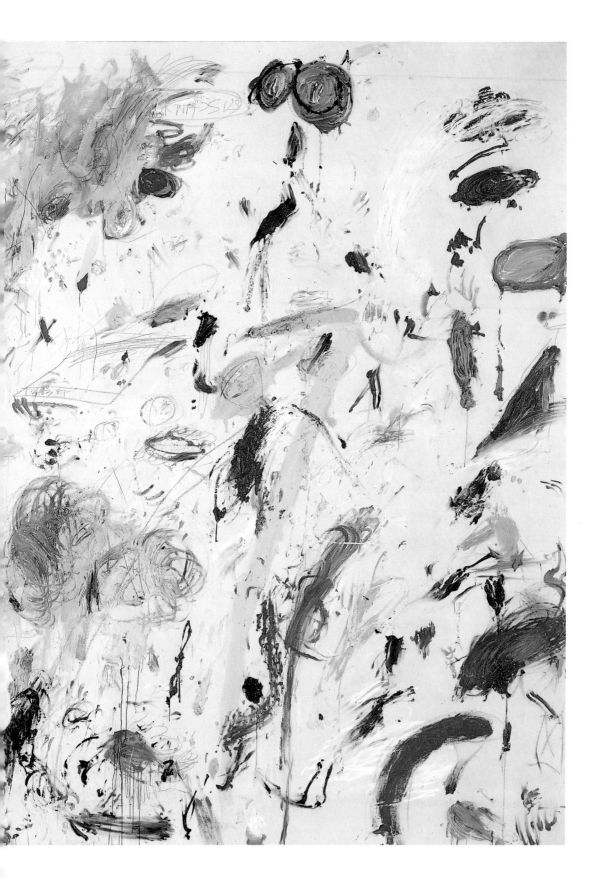

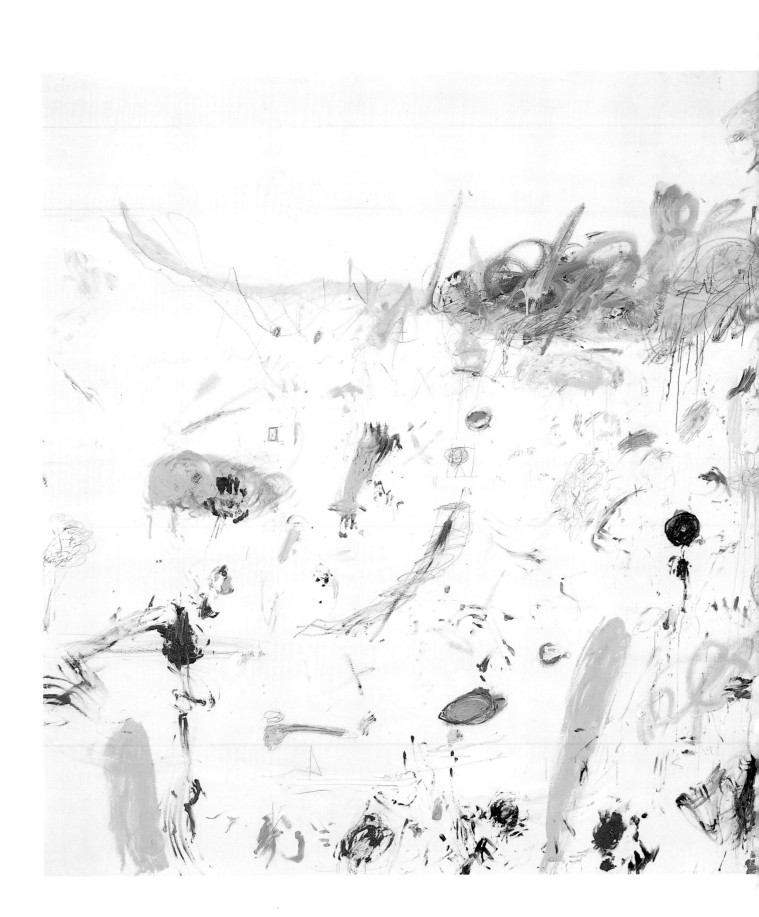

15　Untitled, 1961
*Oil, crayon and pencil on canvas, 202.5 x 240.5 cm*

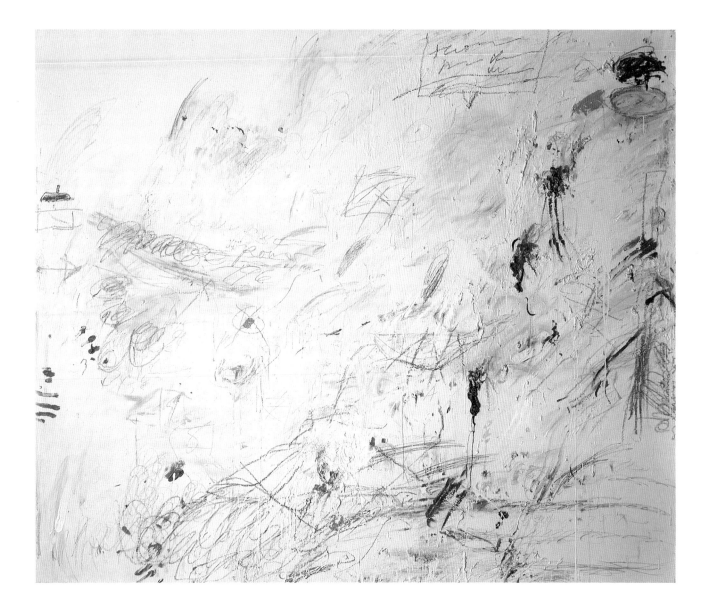

16  Untitled, 1961
*Oil, crayon and pencil on canvas, 256 × 307 cm*

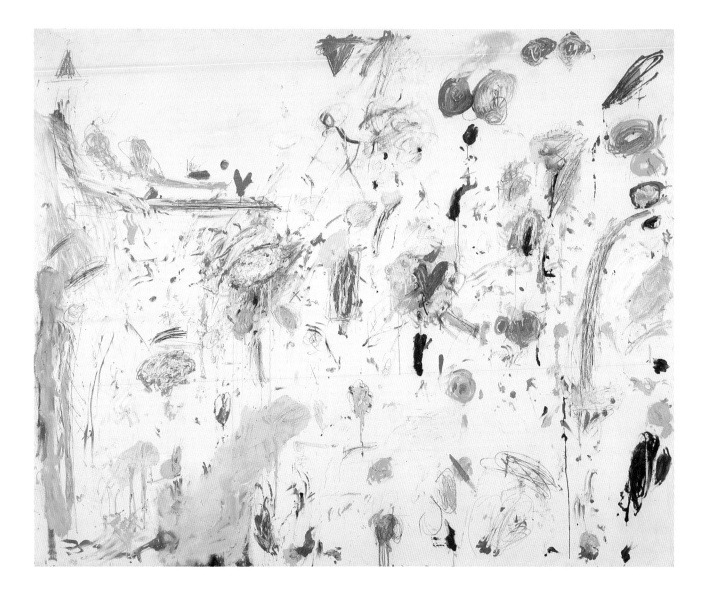

17  August Notes from Rome, 1961
*Oil, crayon and pencil on canvas, 165 × 200 cm*

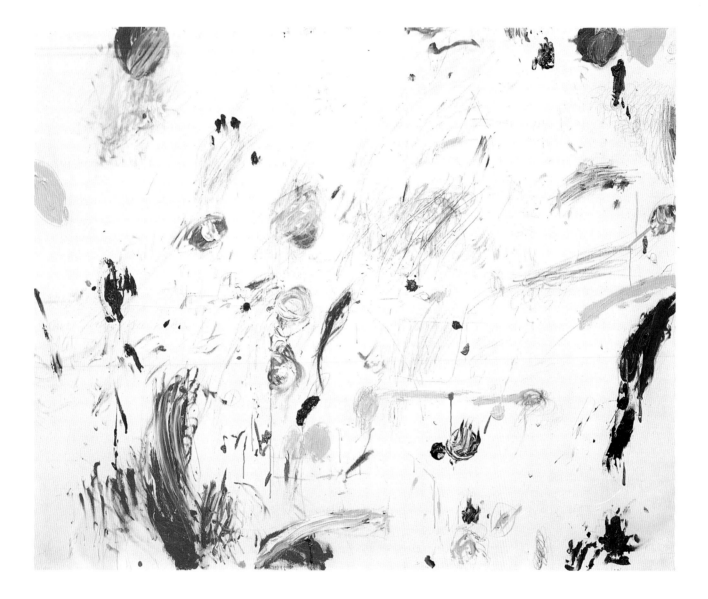

18  Untitled, 1961
*Oil, crayon and pencil on canvas, 165 x 203 cm*

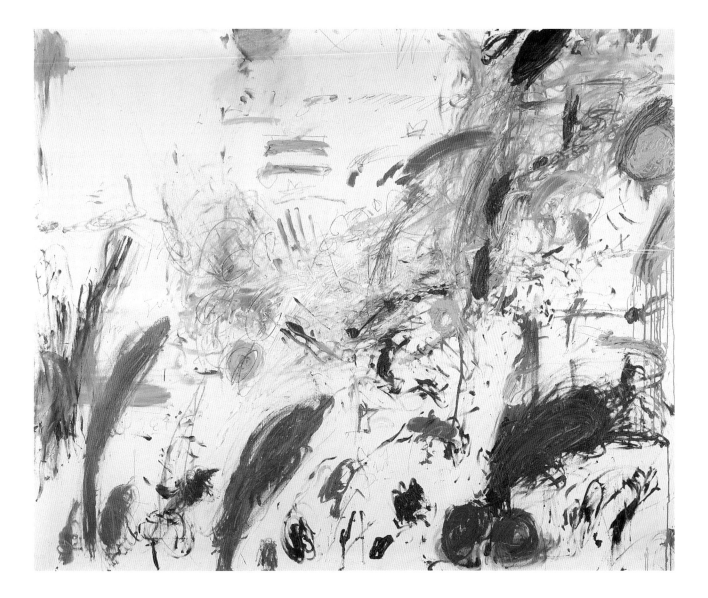

19  Untitled, 1961
*Oil, crayon and pencil on canvas, 164.5 x 200 cm*

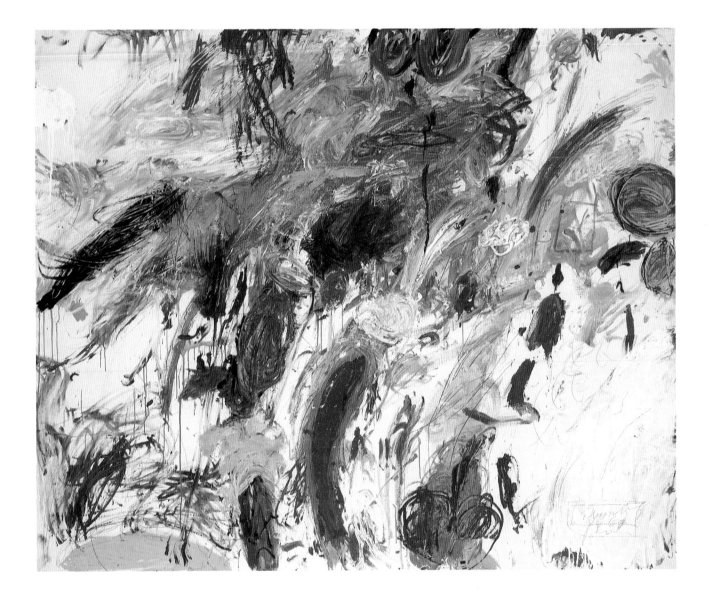

20 Leda and the Swan, 1961
*Oil, crayon and pencil on canvas, 190.5 x 200 cm*

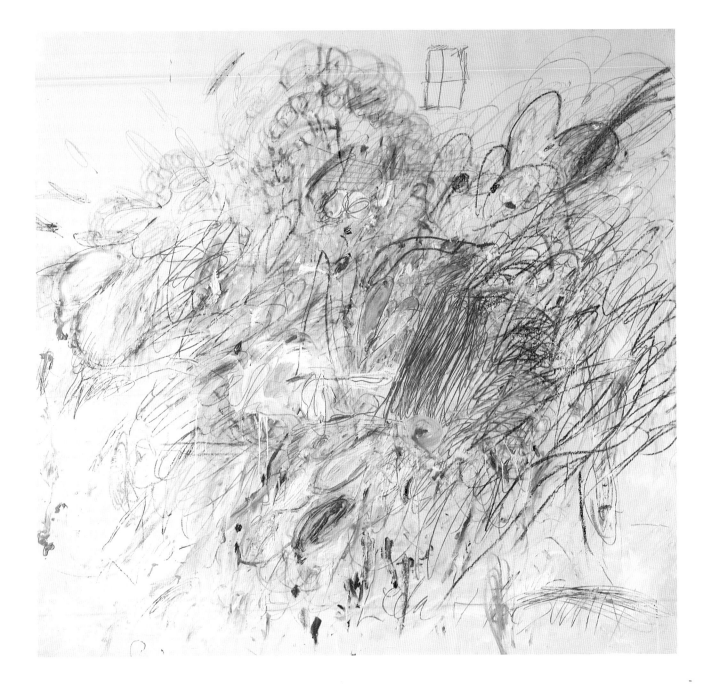

21  Night Watch, 1966
*Distemper and crayon on canvas, 190 × 200 cm*

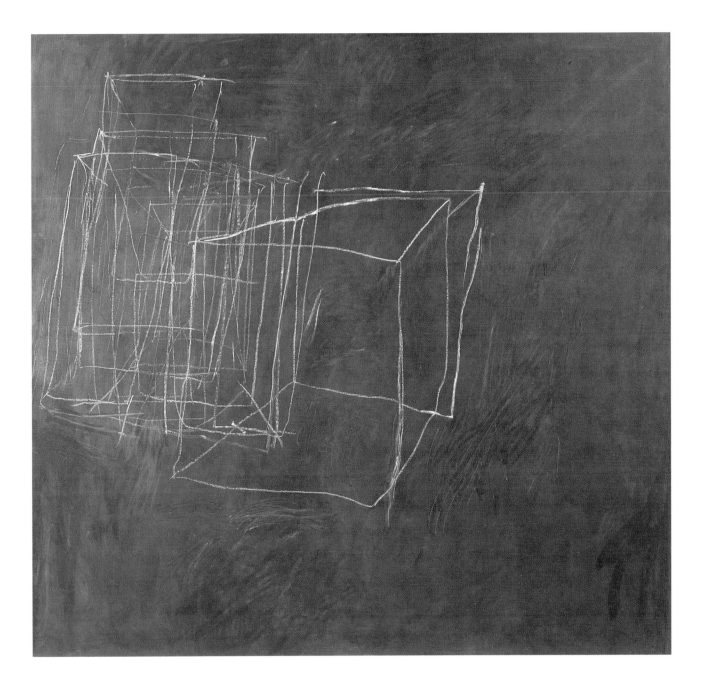

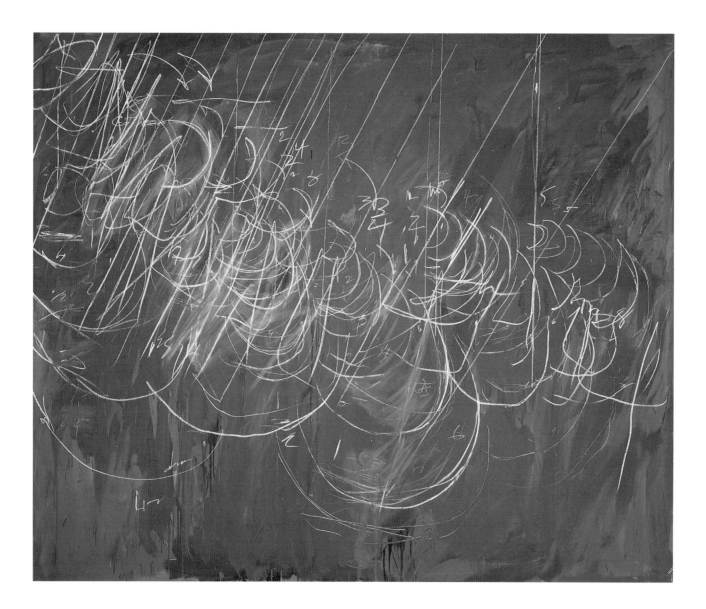

22 Untitled, 1968/1971
*Distemper and chalk on canvas, 200 × 239 cm*

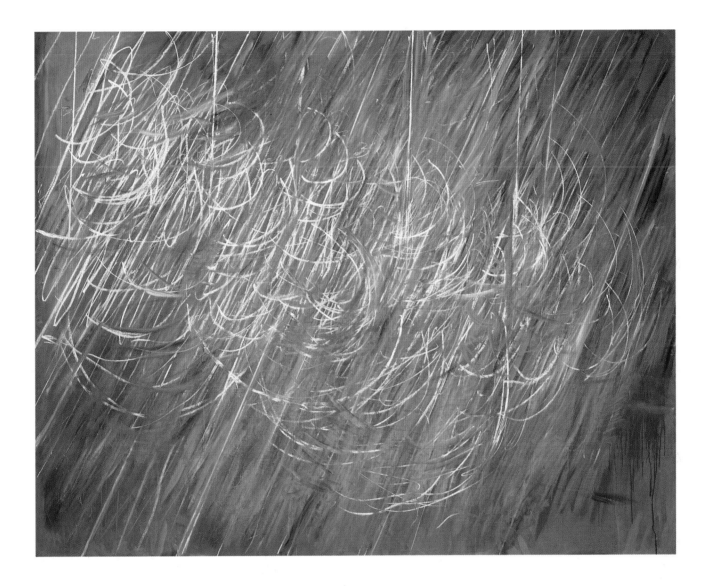

23  Untitled, 1968/1971
*Distemper and chalk on canvas, 199 × 248.2 cm*

24 Untitled, 1970
*Distemper and chalk on canvas, 345.5 × 495.3 cm*

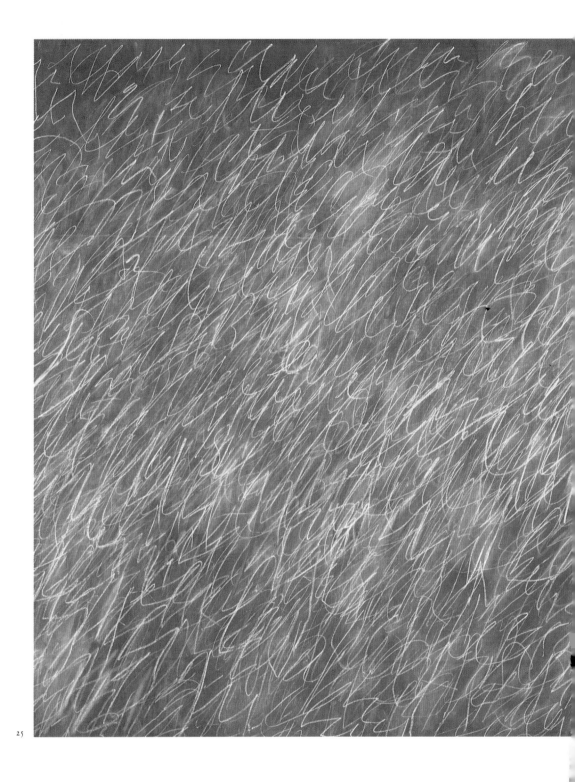

25

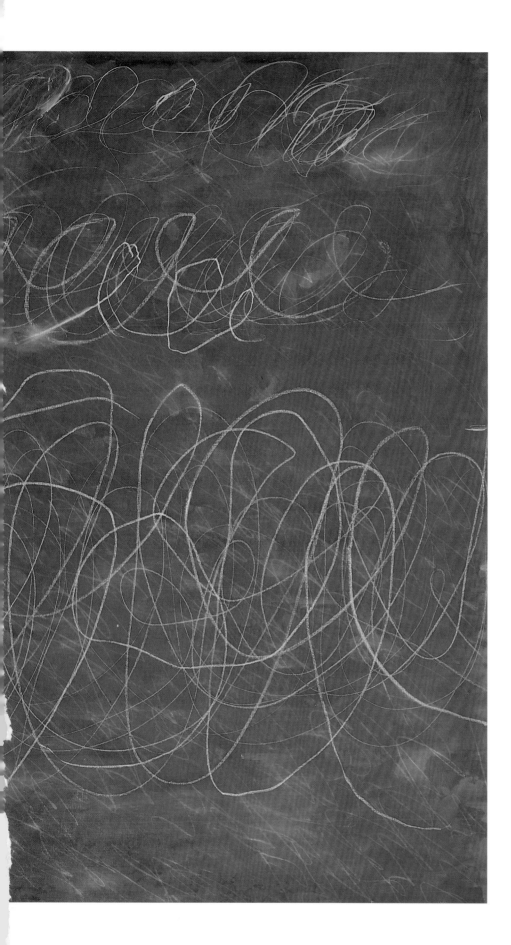

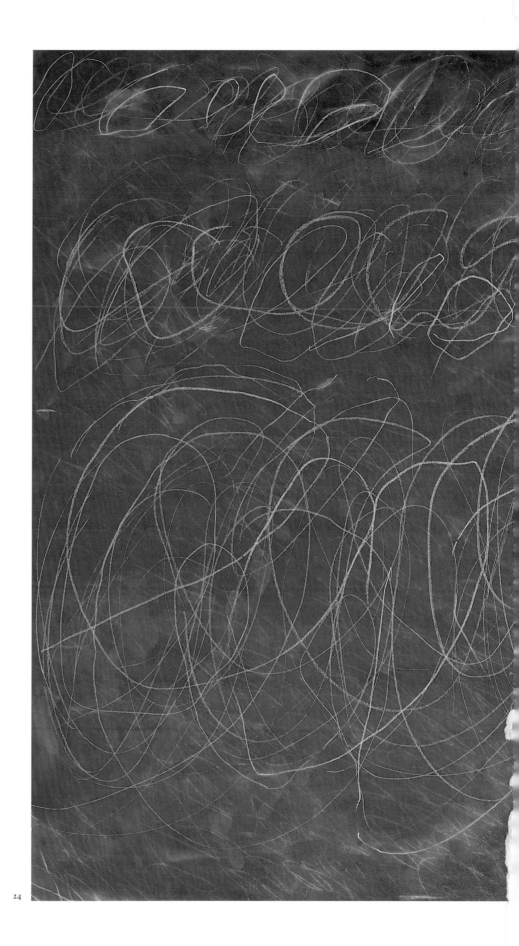

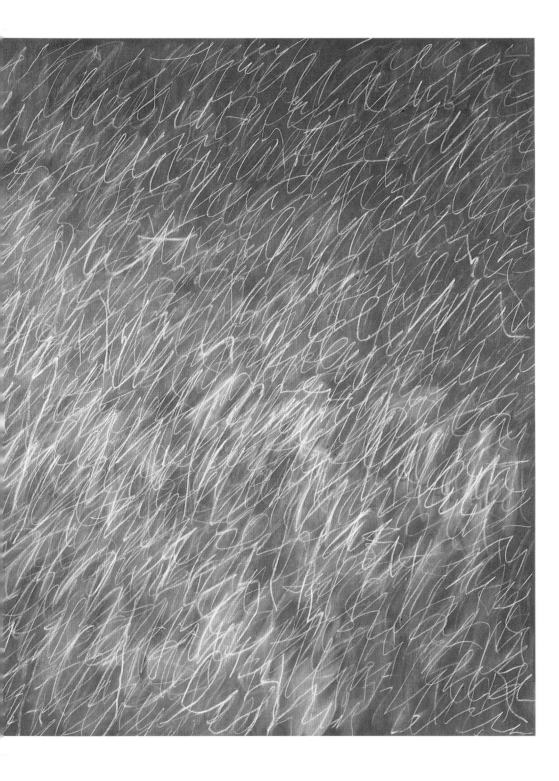

25 Untitled, 1970
*Distemper and chalk on canvas, 405 × 640.3 cm*

26 Untitled, 1968
*Oil, chalk and tempera on cloth, 172.7 × 215.9 cm*

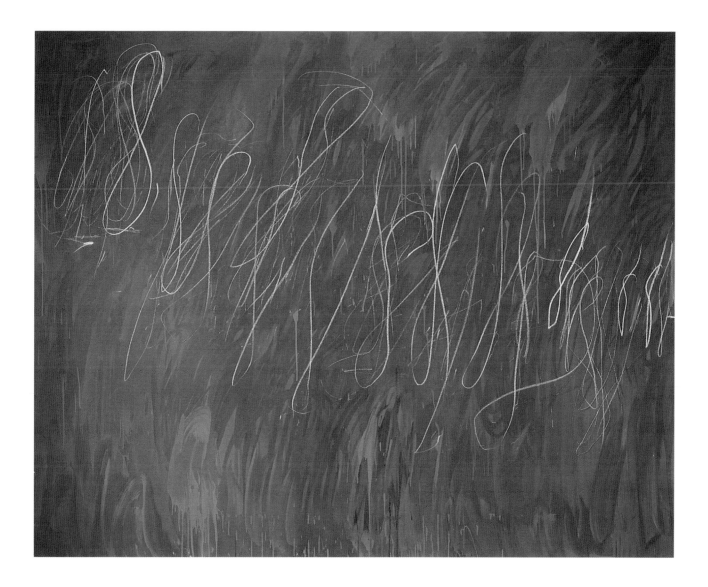

27  Untitled, 1971
*Distemper and chalk on canvas, 198 × 348 cm*

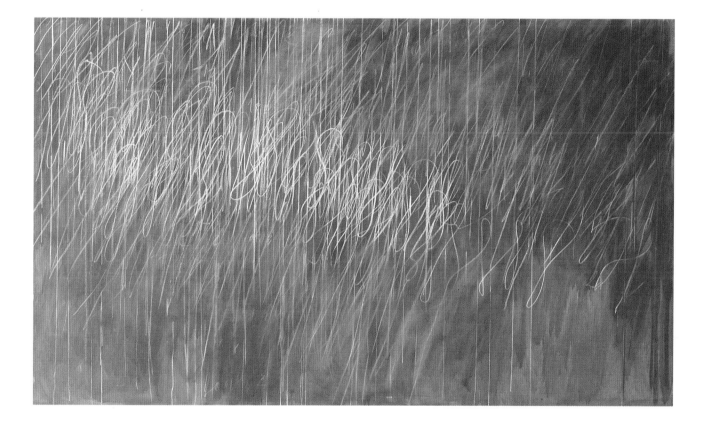

28  Turn and Coda, 1974
*Oil, crayon and pencil on canvas, 251 x 200 cm*

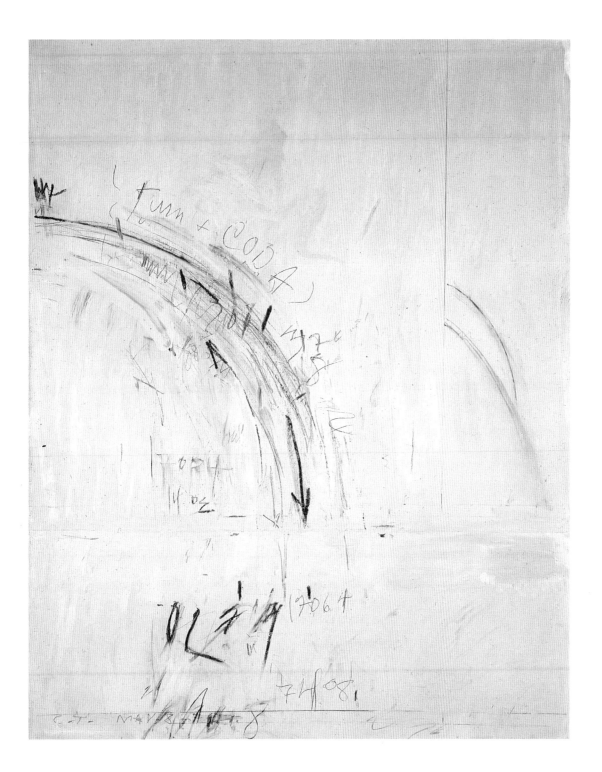

29  Mars and the Artist, 1975
*Collage, oil, crayon, charcoal and pencil on paper, 142 × 127.5 cm*

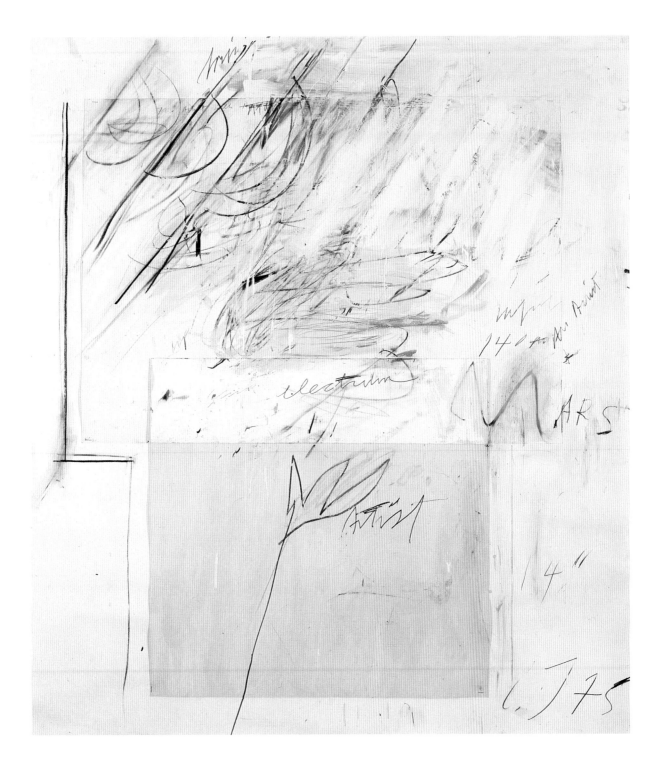

30  Apollo and the Artist, 1975
*Collage, oil, crayon and pencil on paper, 142 × 127.5 cm*

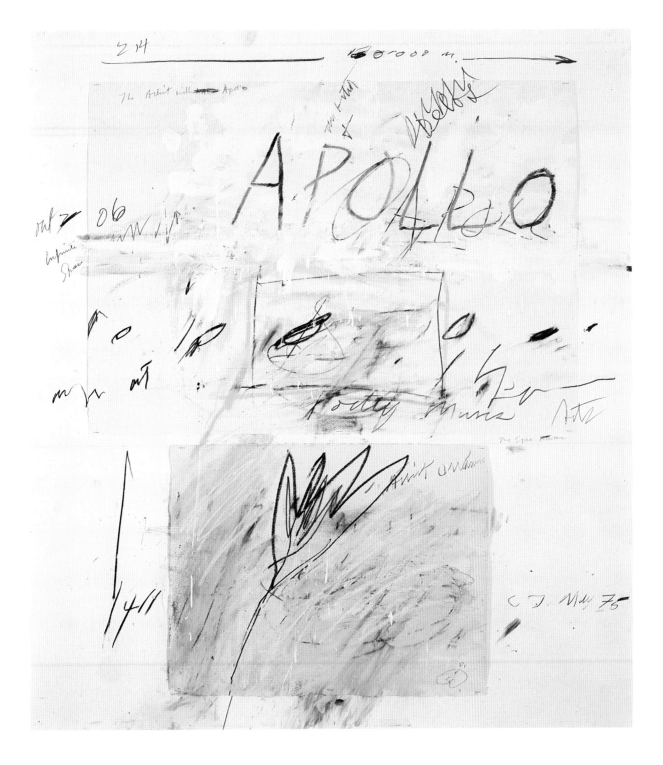

31  Adonais, 1975

*Collage, oil, crayon and pencil on paper, 166.2 × 119 cm*

He is a portion of the Coolness

Which once he made more lovely

ADONAIS

June 2-75

He has out soared the shadow of our night

32  Leda and the Swan, 1976
*Collage, oil, crayon and pencil on paper.*
*Two sections: 149.8 × 132; 62.3 × 67.3 cm*

33  Idylls, 1976
*Collage, oil, watercolour, crayon and pencil on paper.*
*Two sections: 134.3 × 150.3; 69 × 53 cm*

I AM THYRSIS
of ETNA blessed with a
Tuneful Voice

. . .

CT MB 70

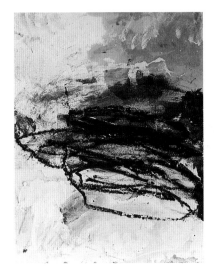

34  Untitled, 1980
*Oil, watercolour, acrylic, crayon, pastel and xerox on paper.*
*Three sections: 65 × 50.5; 119.5 × 152; 33 × 21.5 cm*

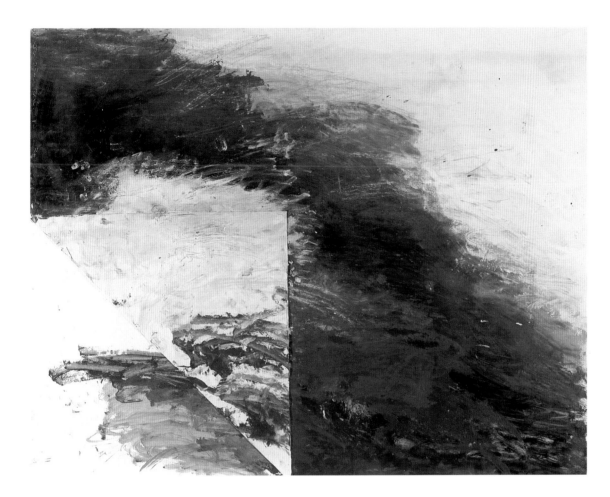

35 Untitled, 1981
*Oil on canvas. Two sections: 153.5 x 107; 28.5 x 42 cm*

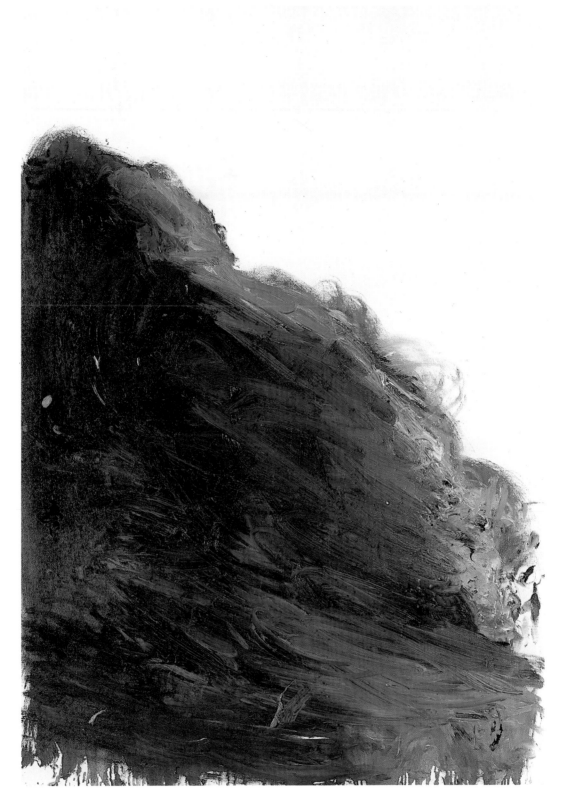

36  Untitled, 1964 and 1984
*Oil and crayon on canvas, 205 × 245 cm*

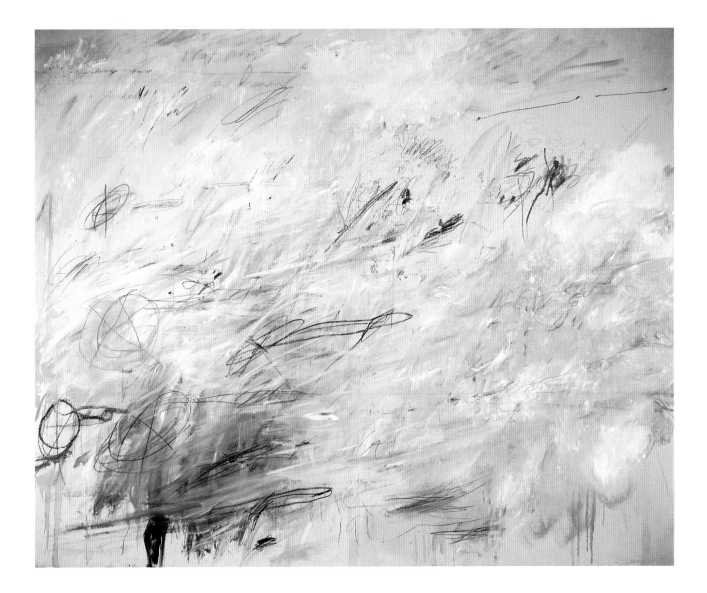

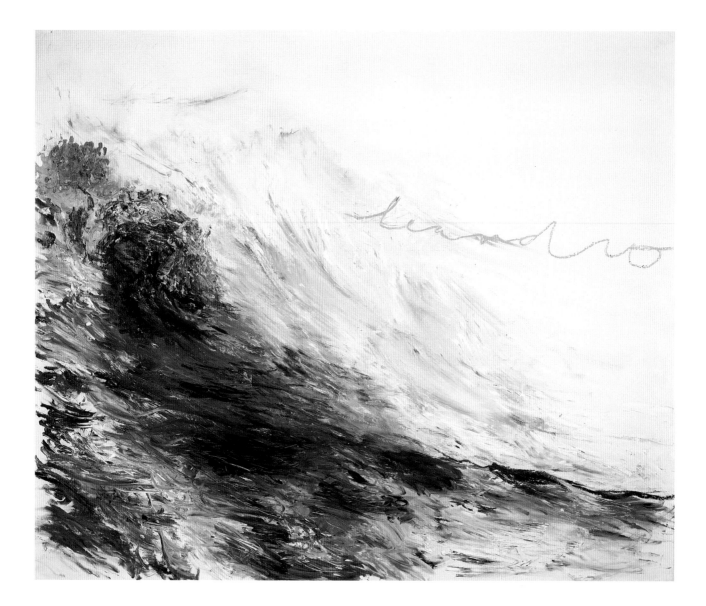

37 Hero and Leander, 1981/1984
*Oil and crayon on canvas.*
*Three sections: 168×205; 174×213; 174×213 cm*
*Framed caption: 'He's gone|up bubbles|all his amorous breath'*

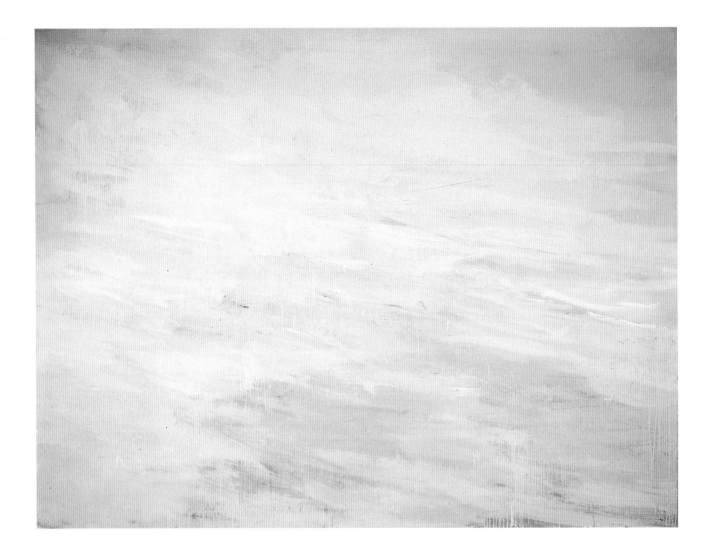

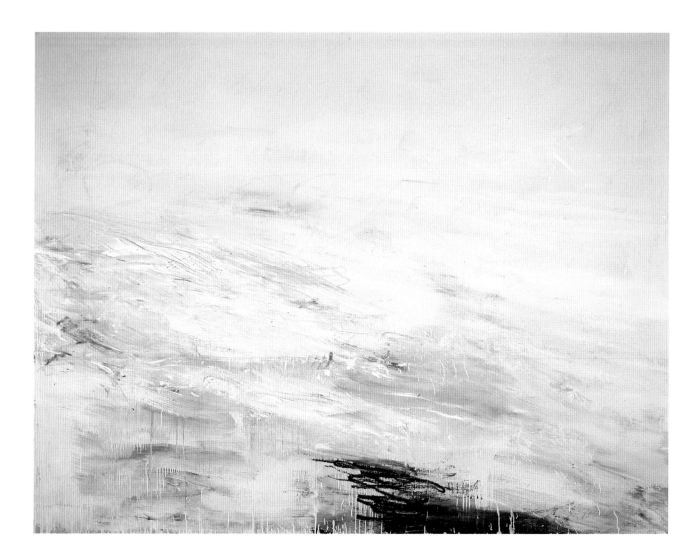

38  Victory, 1984
*Collage, oil, crayon and pastel on cardboard, 168 × 119 cm*

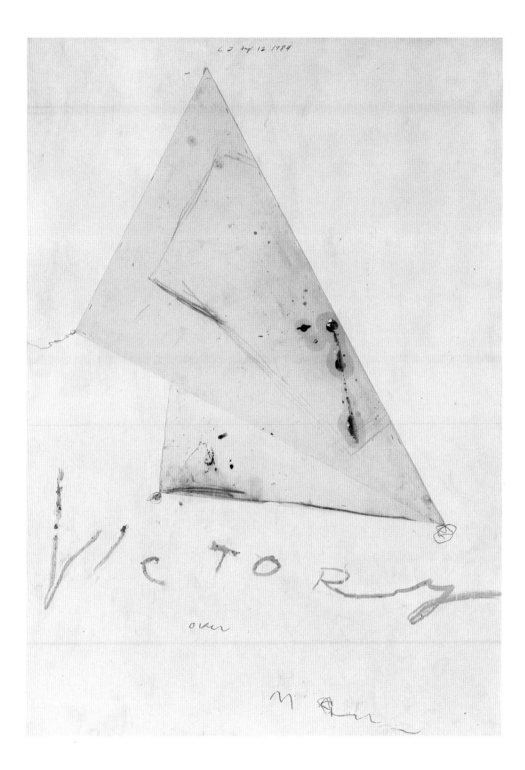

39  Hero and Leander (To Christopher Marlowe), 1984/1985
*Oil on canvas, 202 × 254.1 cm*

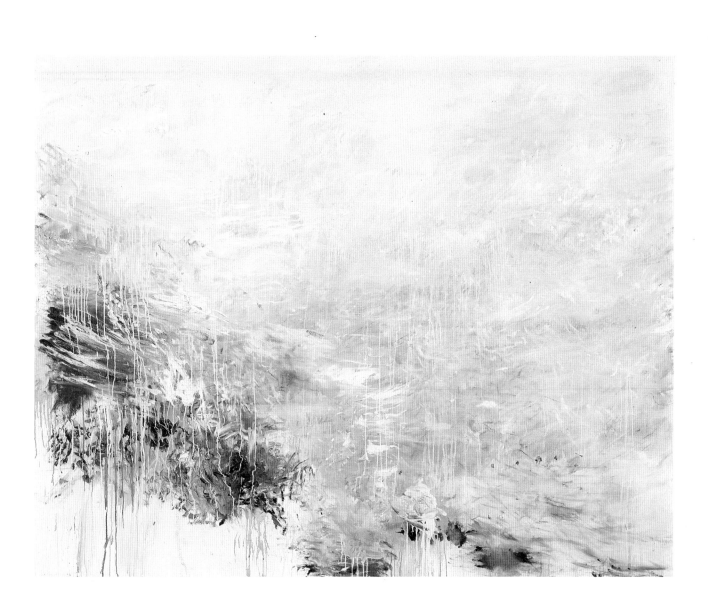

40 Wilder Shores of Love, 1985

*Oil, crayon, coloured pencil and pencil on panel, 140 × 120 cm*

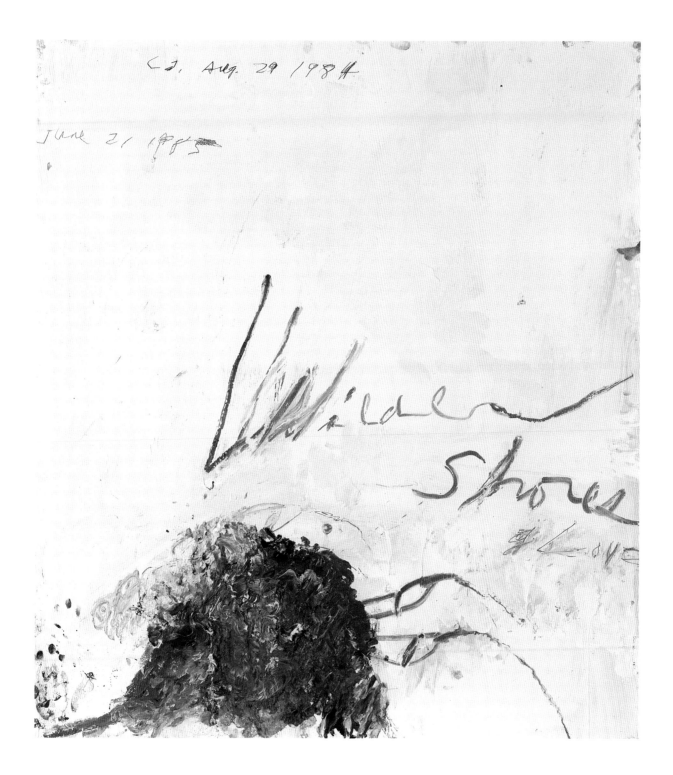

41  Wilder Shores of Love, 1985
*Oil, crayon, coloured pencil and pencil on panel, 140 × 120 cm*

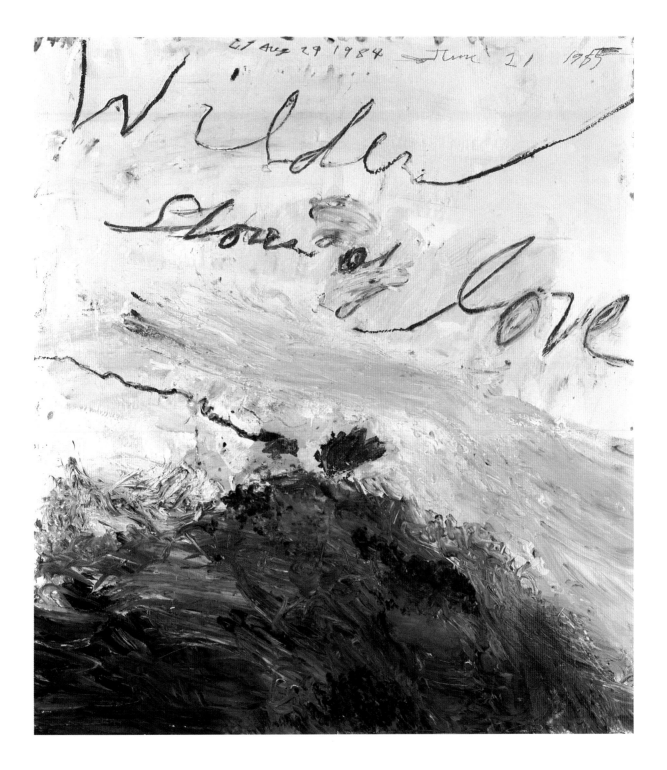

42  Untitled, 1986
*Oil on canvas. Two sections: 120 × 100 ; 40 × 50 cm*

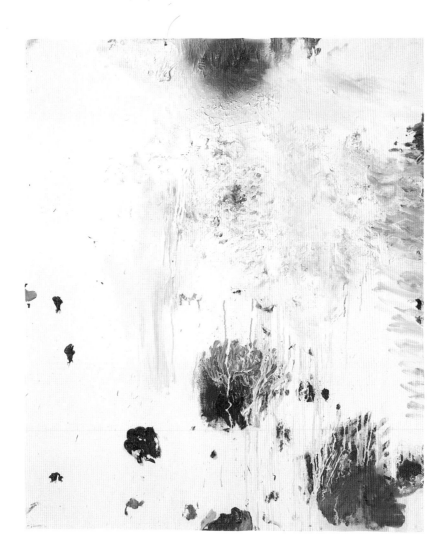
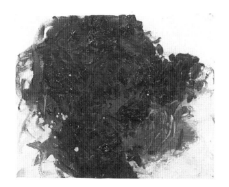

# Works on Paper

43 Untitled, 1953
*Pencil on paper, 33 × 23.6 cm*

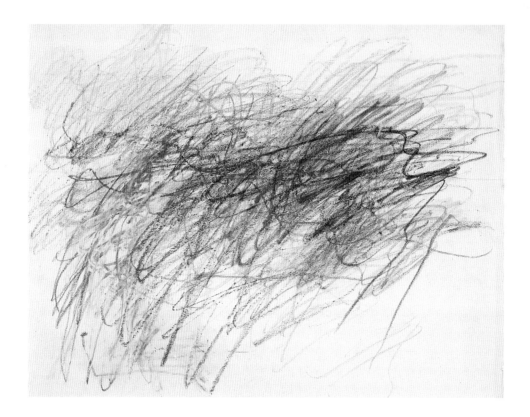

44  Untitled, 1954
*Gouache and crayon on paper, 48.3 × 63.2 cm*

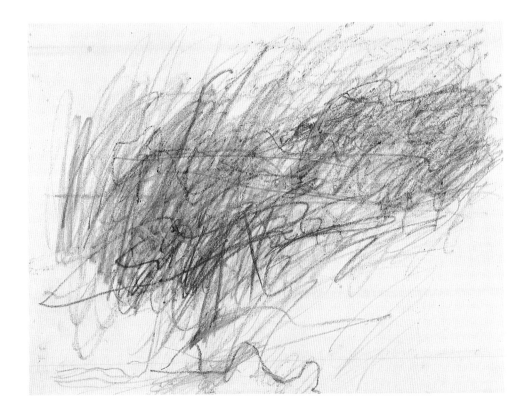

45  Untitled, 1954
*Gouache and crayon on paper, 48.3 × 63.2 cm*

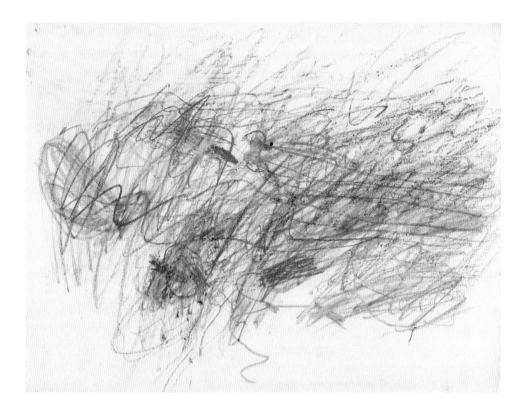

46  Untitled, 1954
*Gouache and crayon on paper, 48.3 × 63.5 cm*

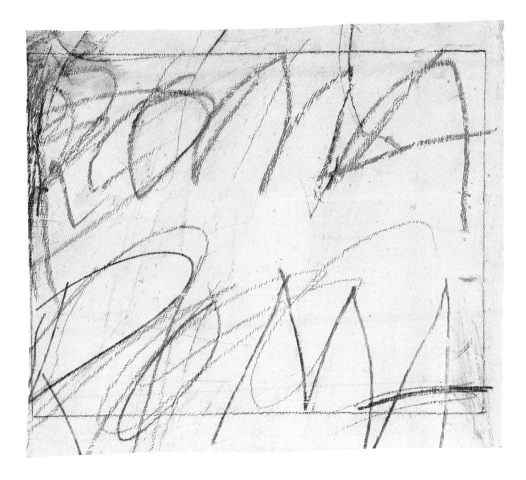

47  Untitled, 1957
*Gouache, crayon and pencil on paper, 31 × 35.8 cm*

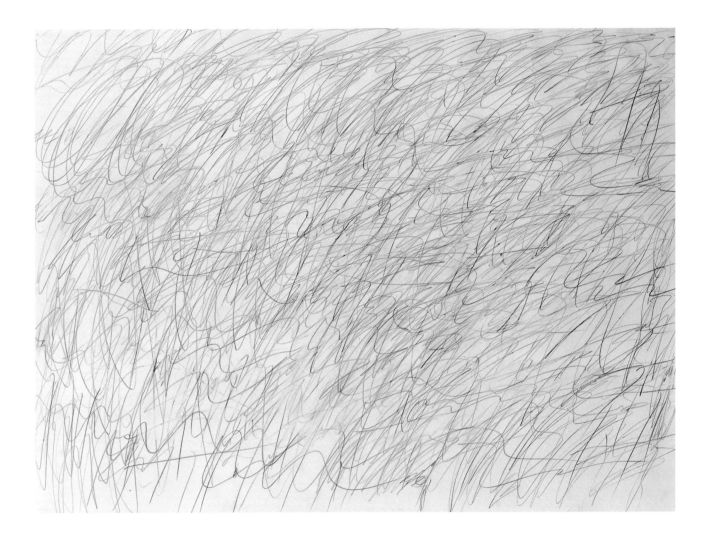

48 Untitled, 1956
*Pencil on paper, 55.8×76 cm*

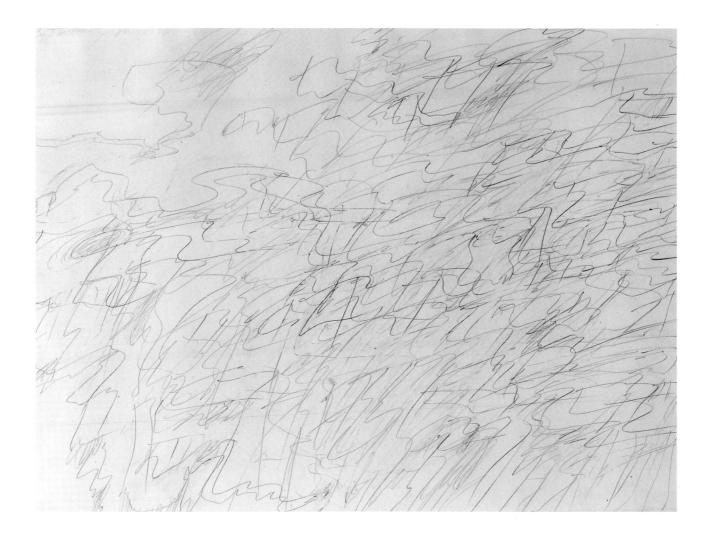

49  Untitled, 1956
*Pencil on paper, 55 × 75.5 cm*

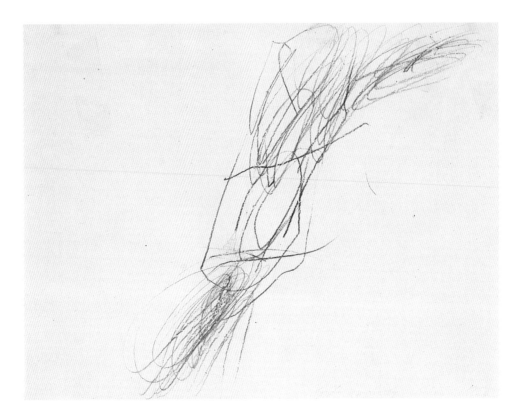

50  Untitled, 1957
*Pencil on paper, 22 × 28.5 cm*

51  Untitled, 1957

*Pencil on paper, 22 × 28.5 cm*

52　Untitled, 1957
*Gouache, crayon and pencil on paper, 70 × 100 cm*

53  Untitled, 1957
*Oil and crayon on cardboard on canvas, 70 × 100 cm*

54  Untitled, 1957
*Gouache, crayon and pencil on paper, 68.5 × 98.2 cm*

55 Untitled, 1958
*Crayon and pencil on paper, 70 × 100 cm*

56  Untitled, 1958
*Crayon and pencil on paper, 69.8 × 99.6 cm*

Cy Twombly
N.Y. City, april 20
1959

57 Untitled, 1959
*Pencil on paper, 61.2 × 91.8 cm*

58  Untitled, 1959

*Pencil on paper, 61.5 × 91.8 cm*

59  Untitled, 1959
*Gouache and pencil on paper, 70 × 99.7 cm*

60  Untitled, 1959
*Gouache on paper on canvas, 70 × 100 cm*

61  Untitled, 1959
*Collage and crayon on paper, 36.3 x 30 cm*

62　Rape of the Sabines, 1960
*Pencil and pen and ink on paper, 50×70.3 cm*

63 Untitled (Triumph of Galatea), 1961
*Crayon, pencil and ball-point pen on paper, 35.5 × 33.3 cm*

64  Untitled (To Lola), 1961
*Oil, crayon, pencil and ball-point pen on paper, 70.3 × 100 cm*

65  Untitled (To Lola), 1961
*Oil, crayon, pencil and ball point pen on paper, 70.3 × 100 cm*

66 Birth of Venus, 1962
*Tempera, crayon, coloured pencil and pencil on paper, 50 × 70.3 cm*

67  Birth of Venus, 1962
*Crayon and pencil on paper, 50×70 cm*

68 Venus and Mars, 1962
*Tempera, crayon, pencil and ball-point pen on cardboard, 50×70.3 cm*

69  Untitled, 1962
*Distemper, crayon and pencil on paper, 70 × 100 cm*

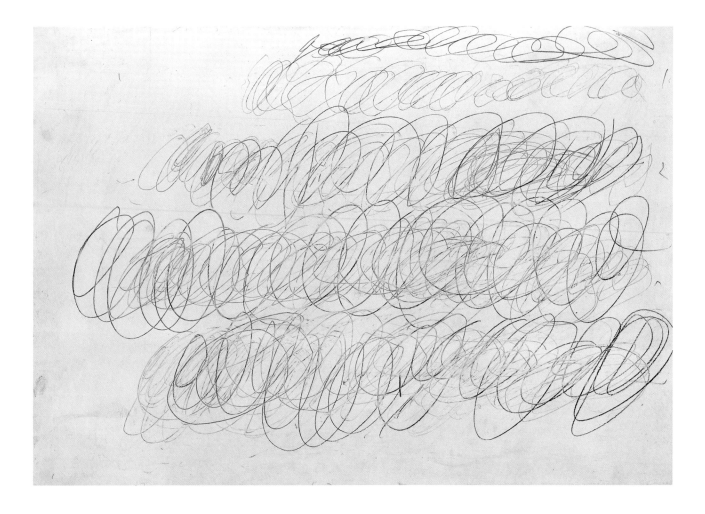

70  Untitled, 1967
*Pencil on paper, 70 × 100 cm*

71  Untitled, 1967
*Pencil on paper, 70 × 100 cm*

72 Untitled, 1969
*Crayon, pencil, pastel and felt-tip pen on paper, 70.3 × 99.7 cm*

73  Untitled, 1969

*Crayon, pencil, pastel and felt-tip pen on paper, 70 × 99.7 cm*

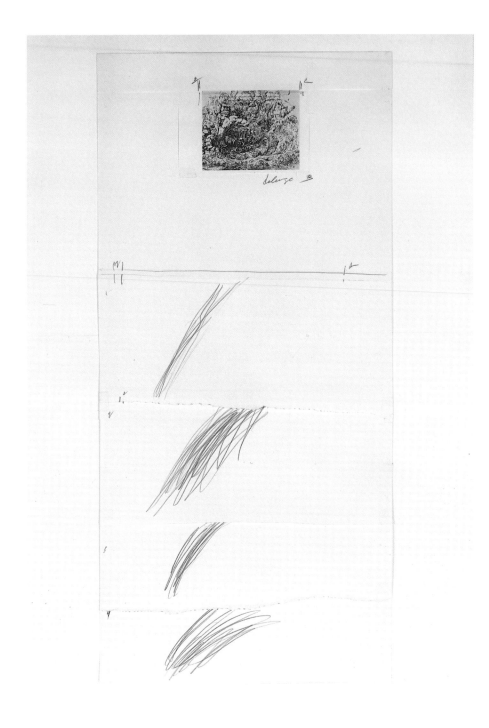

74 Untitled, 1968
*Collage and pencil on paper, 94.7 × 45.5 cm*

75 Untitled ('White Collage'), 1971
*Collage and pencil on cardboard, 91.2 × 69.2 cm*

76  Untitled, 1970
*Collage, crayon and pencil on paper, 69 × 104 cm*

77 Untitled (Study for Treatise on the Veil), 1970
*Collage, oil, crayon and pencil on paper, 70 × 100 cm*

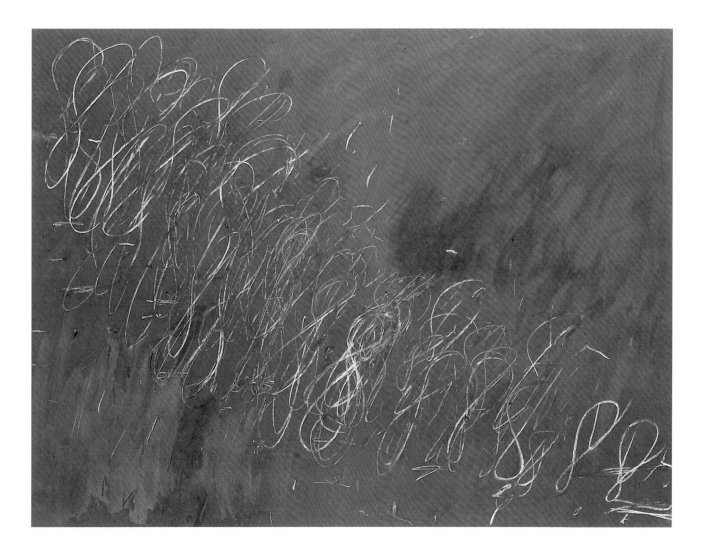

78 Untitled, 1968
*Oil, crayon and gouache on paper, 74 × 102 cm*

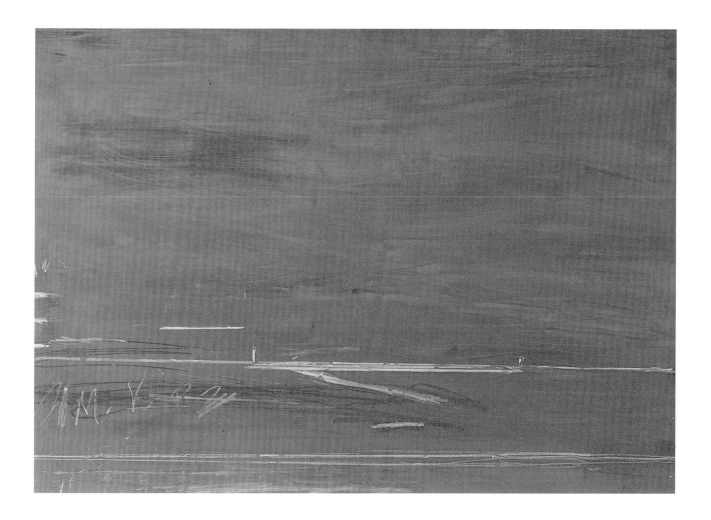

79  Untitled, 1971
*Gouache and crayon on paper, 70.3 × 99.7 cm*

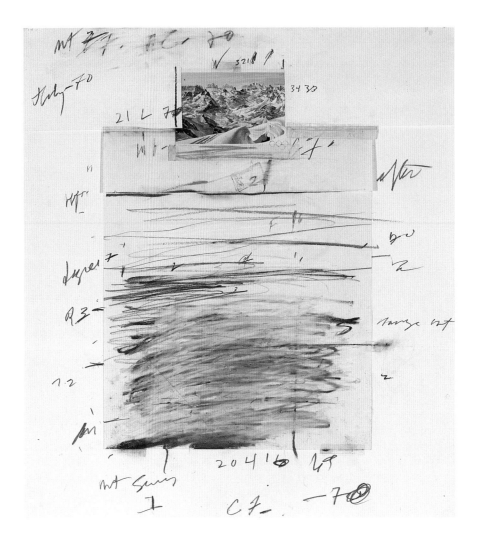

80  Untitled, 1970
*Collage, crayon and pencil on paper, 62.9 × 57 cm*

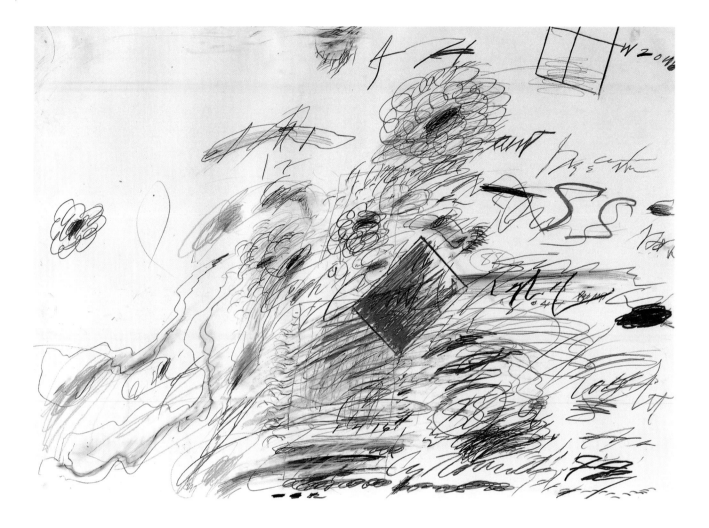

81  Untitled, 1972
*Pencil and chalk on paper, 73 × 101.9 cm*

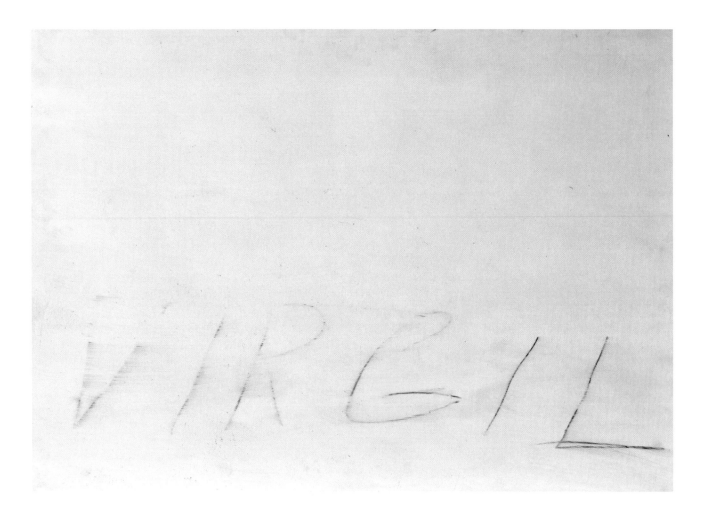

82  Virgil, 1973
*Oil and crayon on paper, 70 × 99.2 cm*

83  To Valéry, 1973
*Collage, oil and crayon on paper, 76.4 × 55.5 cm*

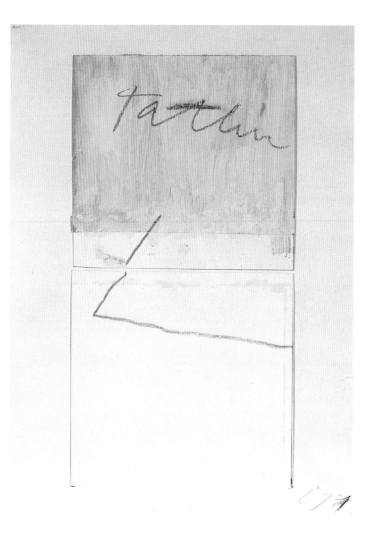

84 To Tatlin, 1974
*Collage, oil and crayon on paper, 76.4 × 55.7 cm*

85  To Montaigne, 1974
*Collage, oil, crayon and pencil on paper, 76.4 × 56 cm*

86  Untitled, 1974
*Collage, crayon and pencil on paper, 75 × 106 cm*

87  Pan, 1975
*Collage, watercolour and pencil on paper, 154 × 106.2 cm*

88  Nike, 1980
*Oil, distemper, tempera, crayon and pencil on paper, 88 × 70.3 cm*

89 Untitled, 1981
*Distemper and crayon on paper, 88.5×70.5 cm*

90  Silex Scintillans, 1981
*Oil, crayon and pencil on paper.*
*Three sections: 100×70; 150.5×135.5; 100×70 cm*

91  Nimphidia, 1982
*Oil, crayon and pencil on paper, 100×71 cm*

( ) July 14 81

92  Nimphidia, 1982
*Oil, crayon and pencil on paper, 100 × 71 cm*

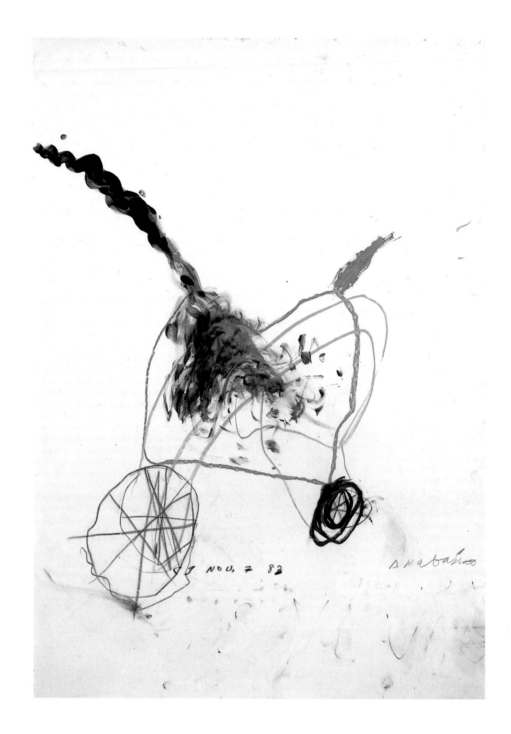

93  Anabasis, 1983
*Oil, crayon and pencil on paper, 100×70 cm*

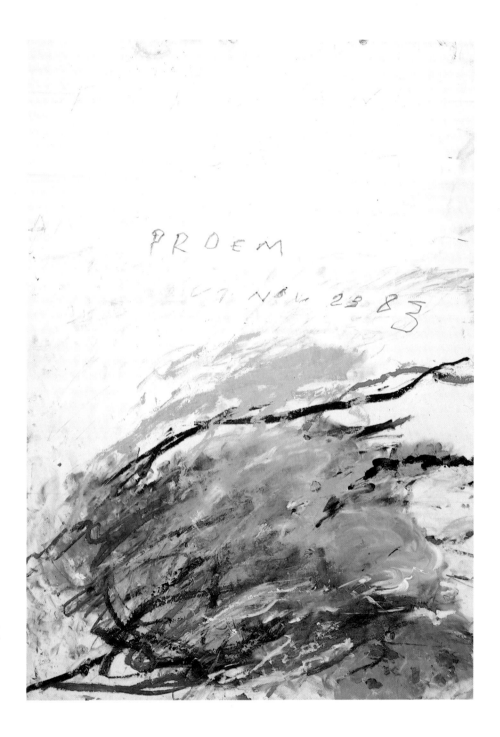

94 Proem, 1983
*Oil, crayon and pencil on paper, 100 × 70 cm*

95  Anabasis, 1983
*Oil, crayon and pencil on paper, 100×70 cm*

96  Anabasis, 1983
*Oil, crayon and pencil on paper, 100 × 70 cm*

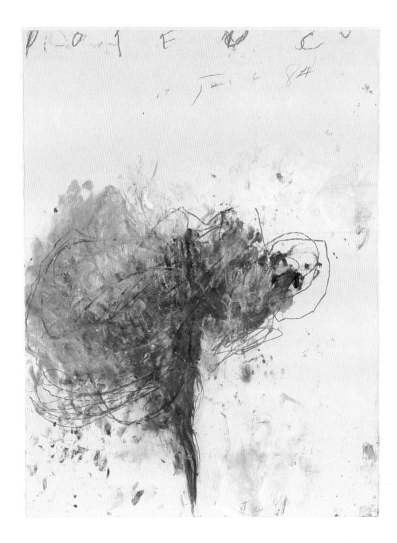

97  Proteus, 1984
*Oil and crayon on paper, 76 × 56.5 cm*

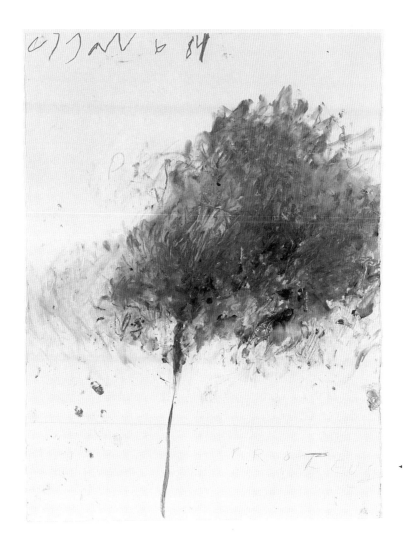

98 Proteus, 1984

*Oil and crayon on paper, 76 × 56.5 cm*

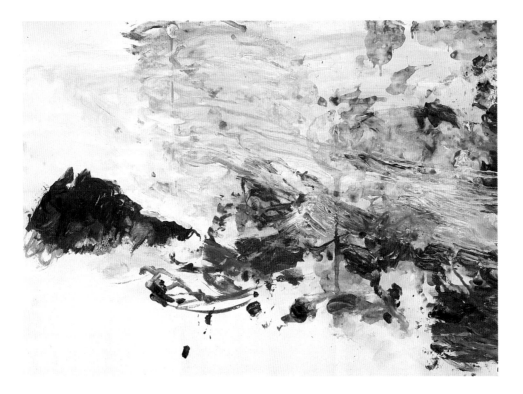

99 Untitled, 1986
*Oil, pastel and gouache on paper, 52×72 cm*

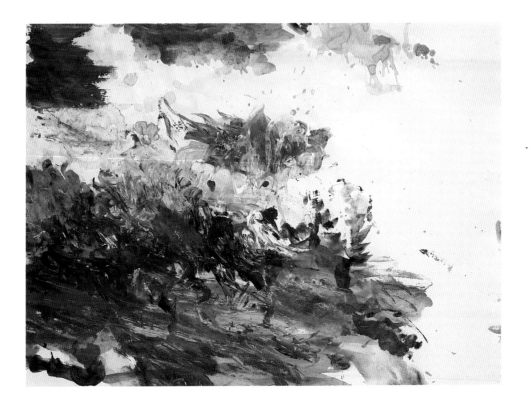

100 Untitled, 1986
*Oil, pastel and gouache on paper, 52×72 cm*

# Sculpture

101  Untitled, 1955
*Wood, cloth, string and matt oil-based wallpaint, 56.5 x 14.3 x 13 cm*

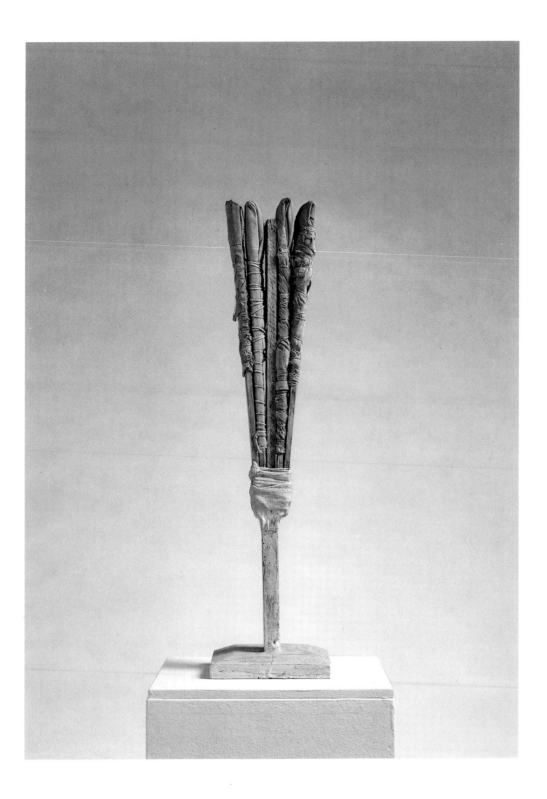

102  Untitled, 1959
*Painted synthetic resin, 55 x 36 x 26 cm*

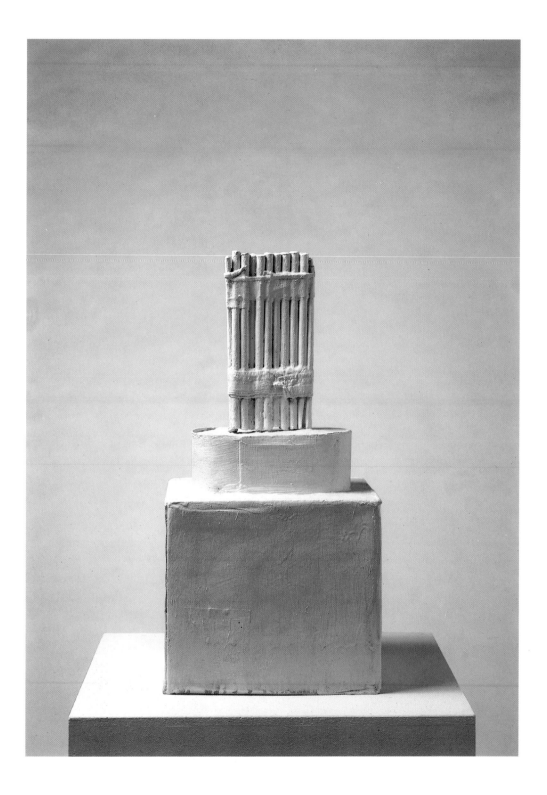

103 Untitled, 1976
*Painted synthetic resin. Height 168 cm; diameter 21.5 cm (bottom) and 16 cm (top)*

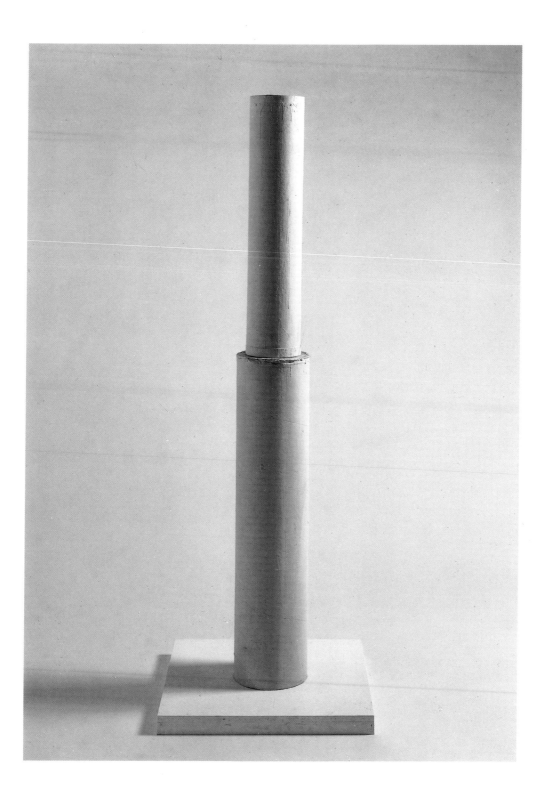

104  Untitled, 1977
*Painted synthetic resin, 87 × 79 × 18.5 cm*

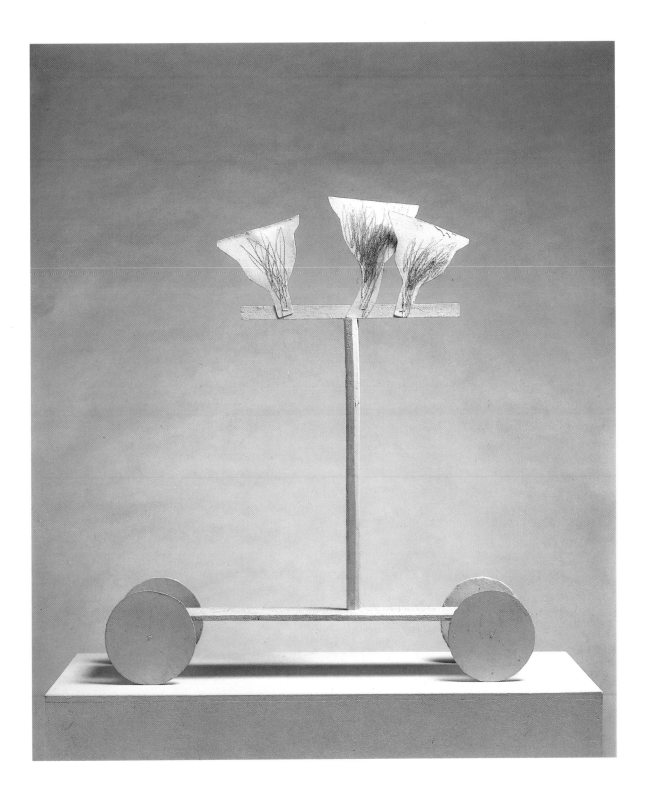

105  Untitled, 1978
*Wood and matt oil-based wallpaint, 23.3 × 51.5 × 32.4 cm*

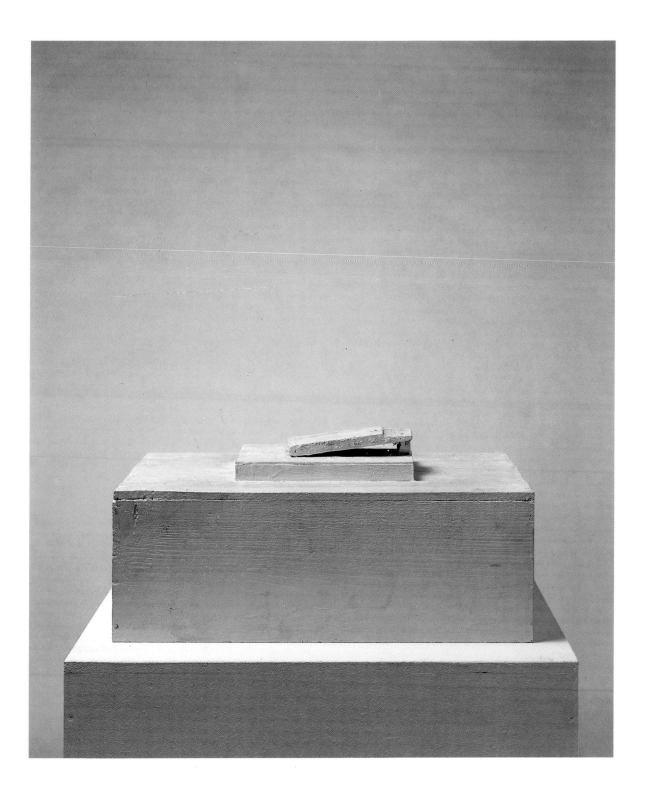

106  Untitled, 1978
*Wood and matt oil-based wallpaint, 31 x 44.5 x 24.3 cm*

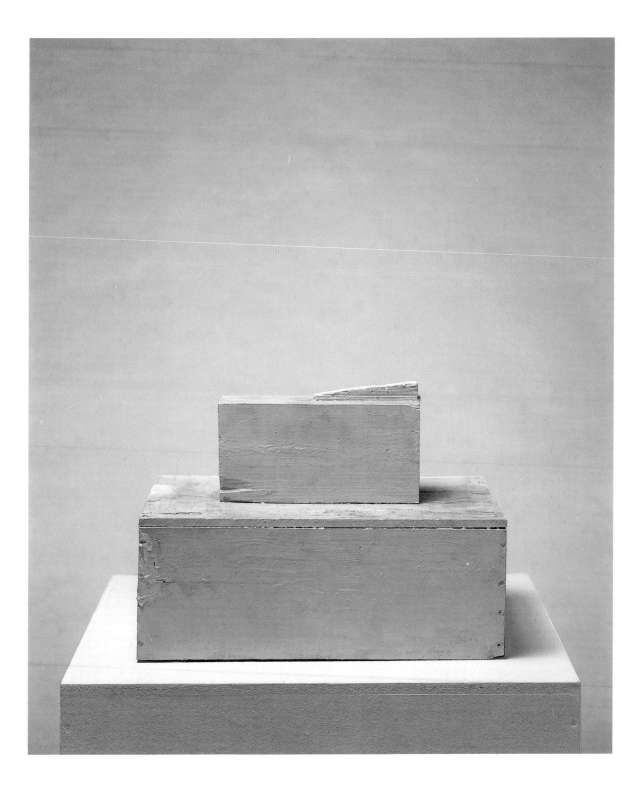

107 Untitled, 1978
*Wood, cloth, wire, nails and matt oil-based wallpaint, 43 x 222.5 x 19.5 cm*

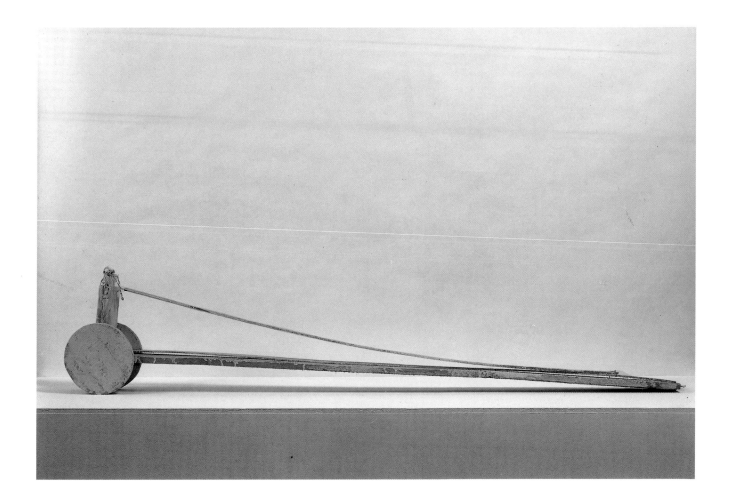

108  Cycnus, 1978
*Painted bronze, 41 × 23.5 × 6 cm*

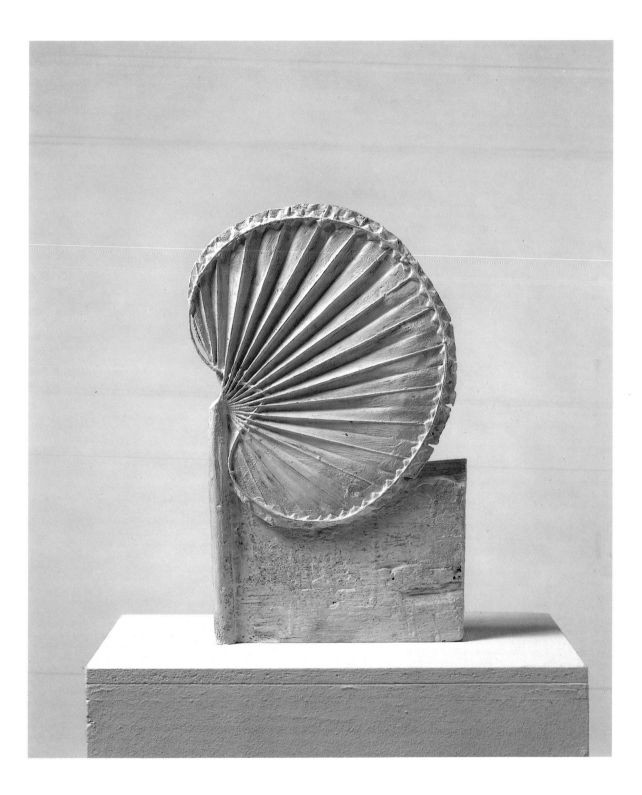

109  Untitled, 1979
*Painted bronze, 49 × 42 × 22 cm*

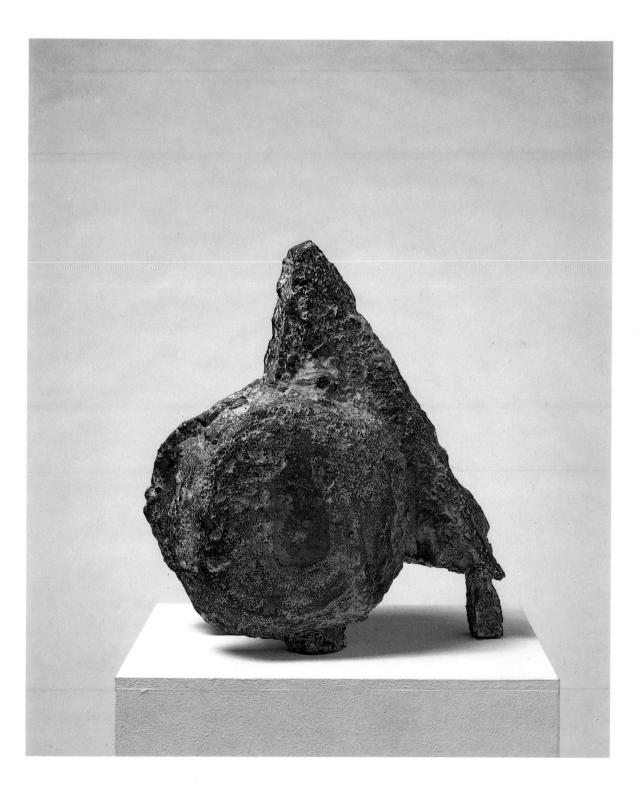

110 Untitled, 1980
*Painted synthetic resin, 41 × 24 × 46 cm*

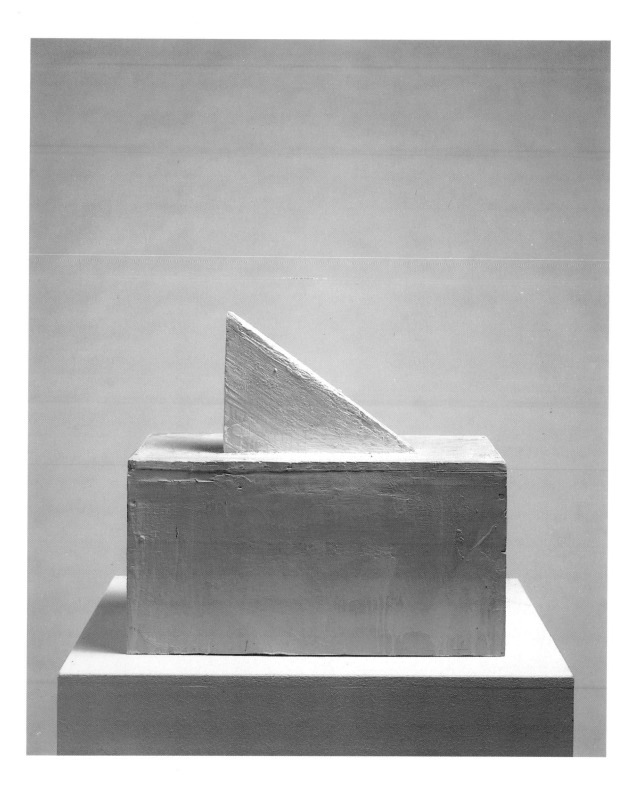

111 Untitled, 1983
*Painted bronze, 179 × 23 × 41 cm*

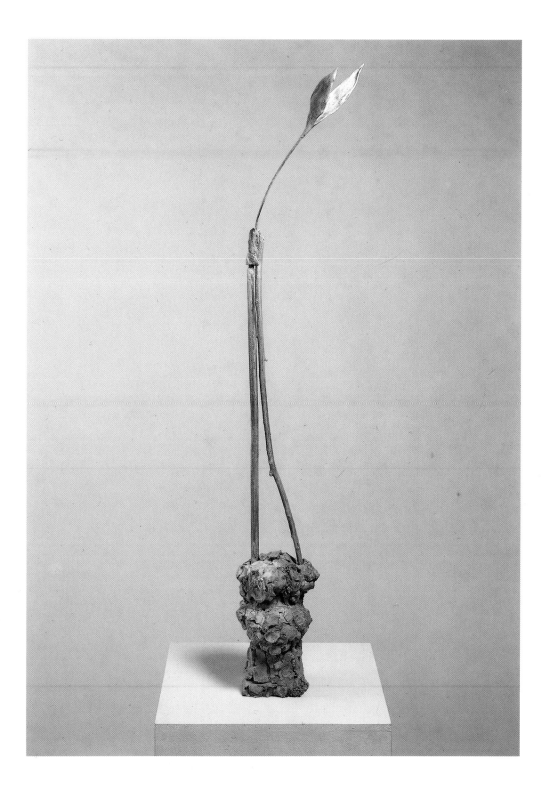

112  Untitled, 1983
*Wood and matt oil-based wallpaint, 186 × 160 × 35 cm*

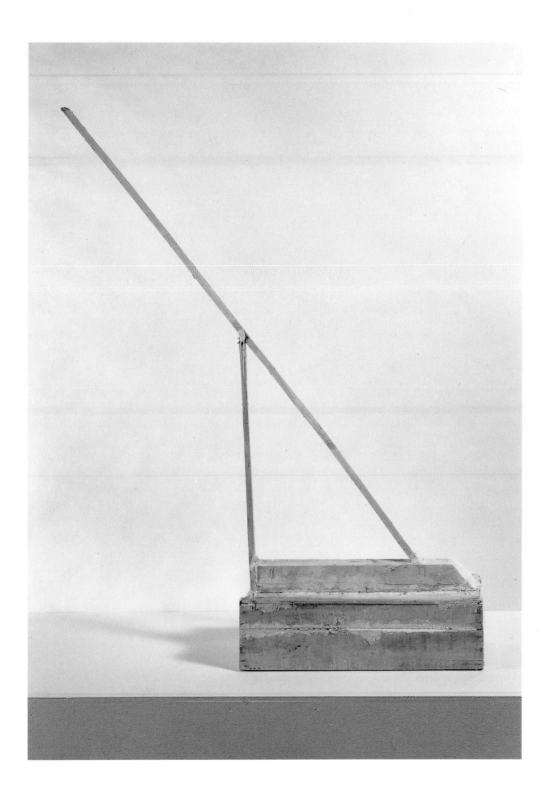

113 Untitled, 1983
*Painted bronze, 142 × 23 × 41 cm*

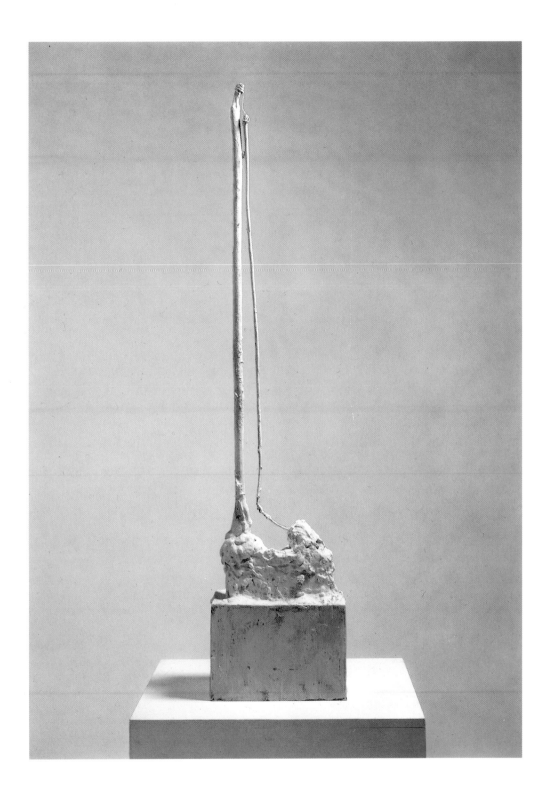

114 Untitled, 1983
*Painted bronze, 82 x 56 x 52 cm*

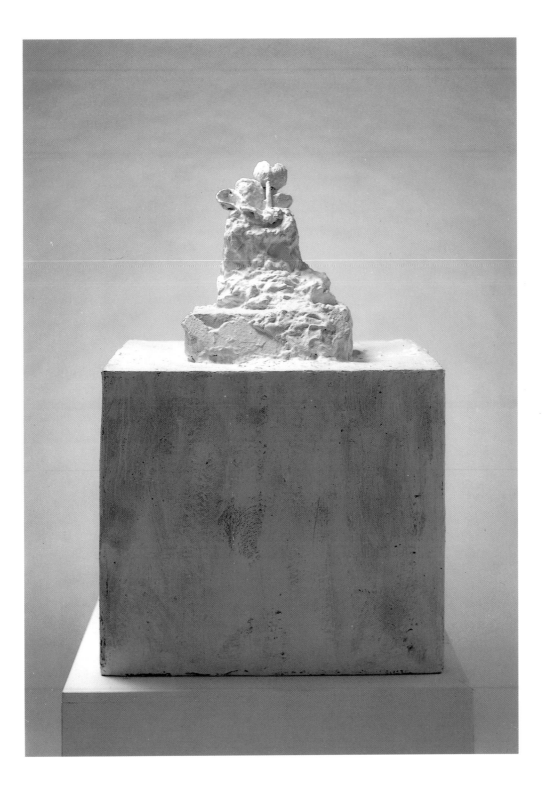

115  Untitled, 1984

*Painted bronze and wood, 121 × 36 × 56.6 cm.*
*Text: 'And we who have always thought of happiness climbing,/would feel the emotion that almost startles when/happiness falls.'*

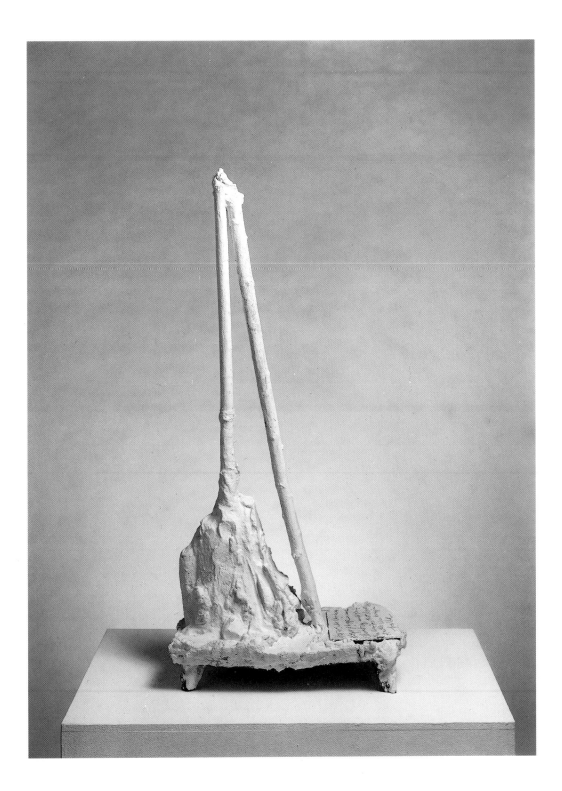

116  Untitled, 1985
*Painted bronze, 175 x 27 x 18.5 cm*

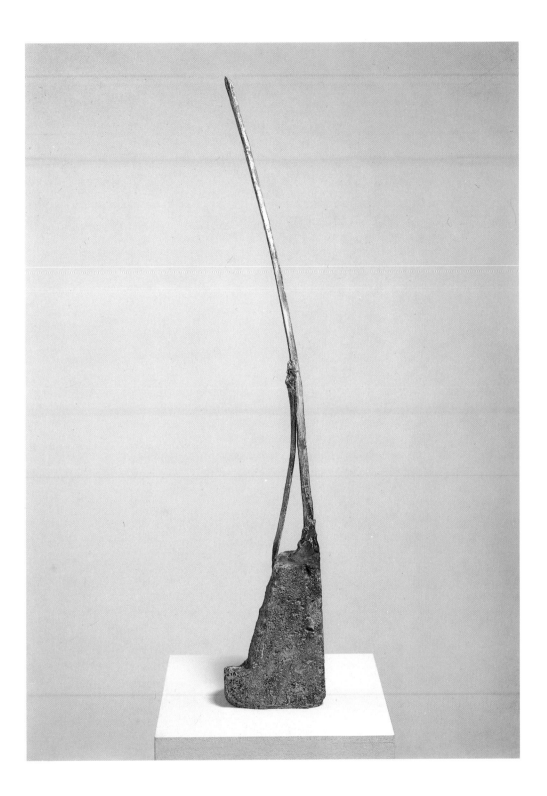

117 Winter's Passage Luxor, 1985
*Painted wood and nails, 54 x 105.7 x 51.6 cm*

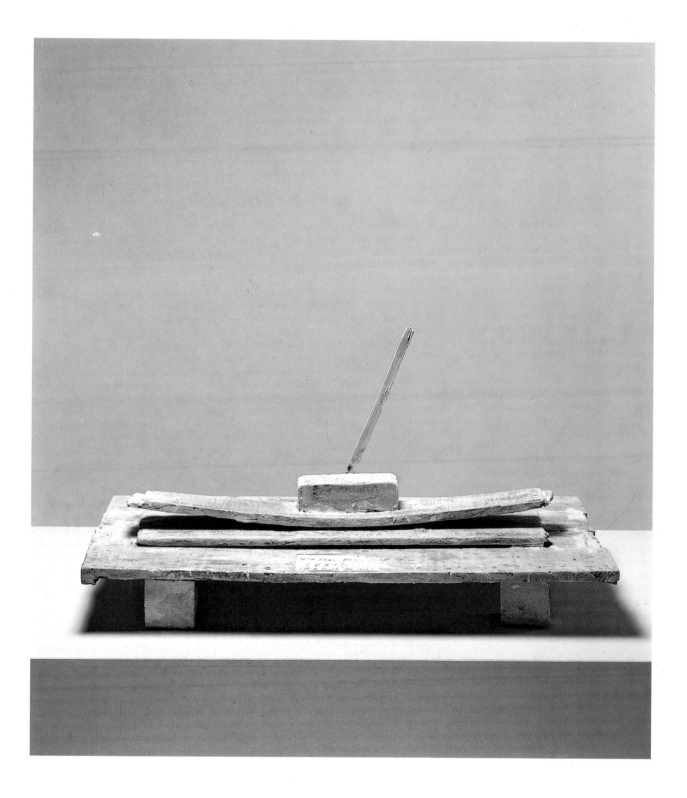

118 Humul, 1986
*Painted bronze, 63 × 84.7 × 38 cm*

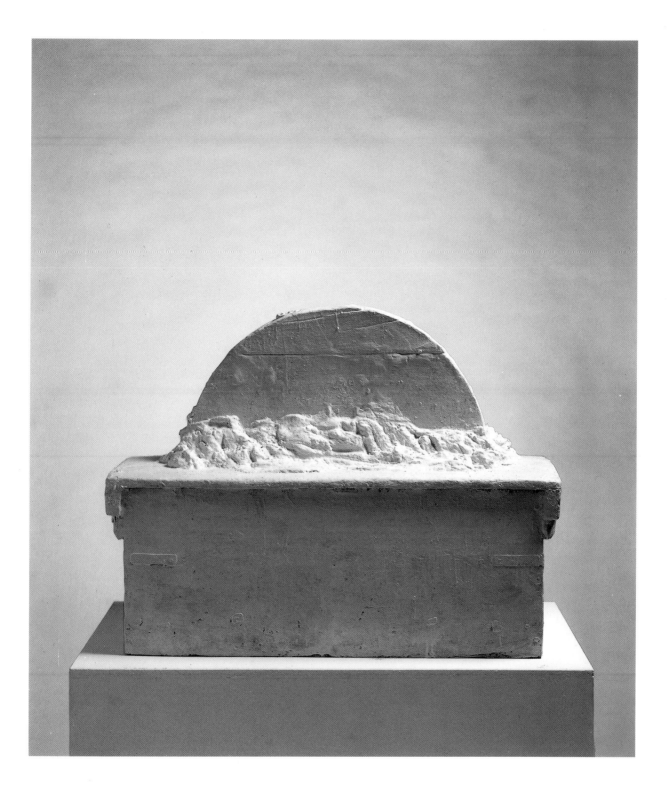

119  Rotalla, 1986
*Painted wood, 82×69×79 cm*

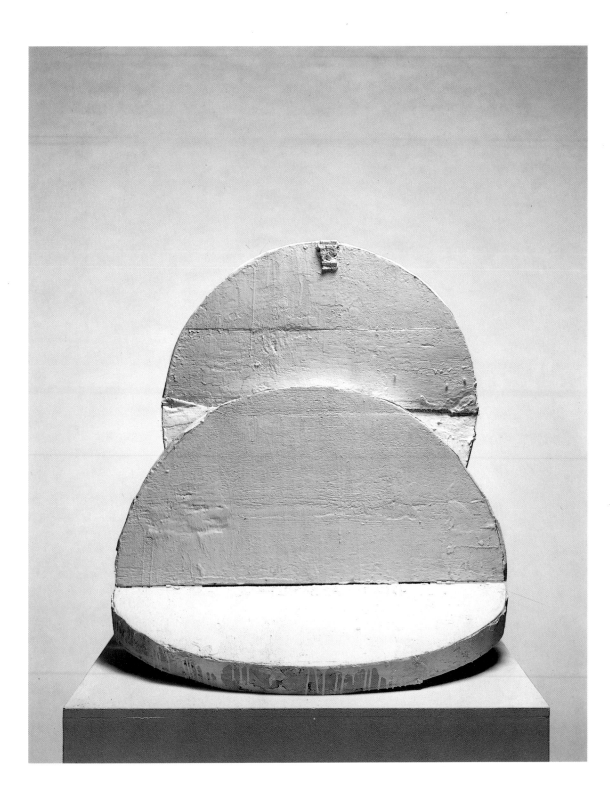

# List of Plates

The abbreviations 'B. A.', 'B' and 'L' refer, respectively, to the catalogues raisonnés of Twombly's paintings (Heiner Bastian), drawings of 1953-1973 (Heiner Bastian) and drawings of 1973-1976 (Yvon Lambert). 'Krefeld' refers to the catalogue accompanying the exhibition of his sculpture in that town in 1981. The place of origin of each work is given in brackets after the title and date.

*Paintings*

1 Untitled, 1952
(New York)
Oil on canvas, 73.5 x 91.5 cm
B. A. 52.1
Öffentliche Kunstsammlung, Kunstmuseum, Basle

2 Untitled, 1954
(New York)
Oil, crayon and pencil on canvas, 174.5 x 218.5 cm
B. A. 54.5
Collection of the artist

3 Untitled, 1954
(New York)
Distemper, crayon and pencil on canvas, 120 x 72 cm
B. A. 54.1
Private collection

4 Panorama, 1955
(New York)
Distemper and crayon on canvas, 254 x 340.5 cm
B. A. 55.1
Courtesy Thomas Ammann, Zurich

5 Free Wheeler, 1955
(New York)
Oil, crayon and pencil on canvas, 174 x 190 cm
B. A. 55.4
Marx Collection, Berlin

6 Untitled, 1955
(Lexington, Virginia)
Oil and graphite on canvas, 71 x 122.5 cm
Private collection

7 Untitled, 1955/1956
(New York)
Oil and graphite on canvas, 114.7 x 135.4 cm
Private collection

8 Untitled, 1955/1956
(New York)
Oil and graphite on canvas, 114.7 x 135.4 cm
Private collection

9 Untitled, 1957
(Rome)
Oil, crayon and pencil on canvas, 174 x 191.4 cm
Private collection

10 Sunset, 1957
(Rome)
Oil, crayon and pencil on canvas, 142.5 x 194 cm
Courtesy Thomas Ammann, Zurich

11 Arcadia, 1957/1958
(Rome)
Oil, crayon and pencil on canvas, 183 x 200 cm
B. A. 58.2
Collection of Nicola Bulgari, New York

12 Untitled, 1959
(Rome)
Oil, crayon and pencil on canvas, 147.7 x 242 cm
Private collection

13 Untitled, 1961
(Rome)
Oil and crayon on canvas, 130 x 150 cm
Private collection

14 Triumph of Galatea, 1961
(Rome)
Oil, crayon and pencil on canvas, 294.3 x 483.5 cm
Collection of the artist

15 Untitled, 1961
(Rome)
Oil, crayon and pencil on canvas, 202.5 x 240.5 cm
B. A. 61.6
Private collection

16 Untitled, 1961
(Rome)
Oil, crayon and pencil on canvas, 256 x 307 cm
B. A. 61.3
Courtesy Thomas Ammann, Zurich

17 August Notes from Rome, 1961
(Rome)
Oil, crayon and pencil on canvas, 165 x 200 cm
Hirshhorn Museum and Sculpture Garden, Smithsonian Institution, Washington, D.C. (Gift of Joseph H. Hirshhorn, 1966)

18 Untitled, 1961
(Rome)
Oil, crayon and pencil on canvas, 165 x 203 cm
Saatchi Collection, London

19 Untitled, 1961
(Rome)
Oil, crayon and pencil on canvas, 164.5 x 200 cm
Marx Collection, Berlin

20 Leda and the Swan, 1961
(Rome)
Oil, crayon and pencil on canvas, 190.5 x 200 cm
B. A. 61.7
Collection of the artist

21 Night Watch, 1966
(Rome)
Distemper and crayon on canvas, 190 x 200 cm
B. A. 66.5
Private collection

22 Untitled, 1968/1971
(Rome)
Distemper and chalk on canvas, 200 x 239 cm
Private collection

23 Untitled, 1968/1971
(Rome)
Distemper and chalk on canvas, 199 x 248.2 cm
Private collection

24 Untitled, 1970
(Rome)
Distemper and chalk on canvas, 345.5 x 495.3 cm
Collection of the artist

25 Untitled, 1970
(Rome)
Distemper and chalk on canvas, 405 x 640.3 cm
Collection of the artist

26 Untitled, 1968
(New York)
Oil, chalk and tempera on cloth, 172.7 x 215.9 cm
Galerie Karsten Greve, Cologne

27 Untitled, 1971
(Rome)
Distemper and chalk on canvas, 198 x 348 cm
B. A. 71.2
Private collection

28 Turn and Coda, 1974
(Rome)
Oil, crayon and pencil on canvas, 251 x 200 cm
B. A. 74.1
Private collection, Rome

29 Mars and the Artist, 1975
(Rome)
Collage, oil, crayon, charcoal and pencil on paper,
142 x 127.5 cm
B. A. 75.2
Alessandro Twombly

30 Apollo and the Artist, 1975
(Rome)
Collage, oil, crayon and pencil on paper, 142 x 127.5 cm
B. A. 75.1
Alessandro Twombly

31 Adonais, 1975
(Rome)
Collage, oil, crayon and pencil on paper, 166.2 x 119 cm
B. A. 75.2
Private collection

32 Leda and the Swan, 1976
(Rome)
Collage, oil, crayon and pencil on paper.
Two sections: 149.8 x 132; 62.3 x 67.3 cm
B. A. 76.2
Private collection

33 Idylls, 1976
(Rome)
Collage, oil, watercolour, crayon and pencil on paper.
Two sections: 134.3 x 150.3; 69 x 53 cm
Private collection

34 Untitled, 1980
(Bassano)
Oil, watercolour, acrylic, crayon, pastel and xerox on paper.
Three sections: 65 x 50.5; 119.5 x 152; 33 x 21.5 cm
Collection of the artist

35 Untitled, 1981
(Bassano)
Oil on canvas. Two sections: 153.5 x 107; 28.5 x 42 cm
Private collection

36 Untitled, 1964 and 1984
(Rome and Bassano)
Oil and crayon on canvas, 205 x 245 cm
Emily Fisher Landau, New York

37 Hero and Leander, 1981/1984
(Bassano)
Oil and crayon on canvas.
Three sections: 168 x 205; 174 x 213; 174 x 213 cm
Framed caption: 'He's gone / up bubbles / all his amorous
breath'
Karsten Greve, Cologne

38 Victory, 1984
(Bassano)
Collage, oil, crayon and pastel on cardboard, 168 x 119 cm
Collection of the artist

39 Hero and Leander (To Christopher Marlowe),
1984/1985
(Bassano)
Oil on canvas, 202 x 254.1 cm
Collection of the artist

40 Wilder Shores of Love, 1985
(Bassano)
Oil, crayon, coloured pencil and pencil on panel,
140 x 120 cm
Collection of the artist

41 Wilder Shores of Love, 1985
(Rome)
Oil, crayon, coloured pencil and pencil on panel,
140 x 120 cm
Collection of the artist

42 Untitled, 1986
(Bassano)
Oil on canvas. Two sections: 120 x 100; 40 x 50 cm
Private collection

*Works on Paper*

43 Untitled, 1953
   (Tangier)
   Pencil on paper, 33 x 23.6 cm
   B 1
   Collection of the artist

44 Untitled, 1954
   (New York)
   Gouache and crayon on paper, 48.3 x 63.2 cm
   Robert Rauschenberg

45 Untitled, 1954
   (New York)
   Gouache and crayon on paper, 48.3 x 63.2 cm
   Robert Rauschenberg

46 Untitled, 1954
   (New York)
   Gouache and crayon on paper, 48.3 x 63.5 cm
   Robert Rauschenberg

47 Untitled, 1957
   (Rome)
   Gouache, crayon and pencil on paper, 31 x 35.8 cm
   B 14
   Collection of the artist

48 Untitled, 1956
   (Buena Vista)
   Pencil on paper, 55.8 x 76 cm
   Private collection

49 Untitled, 1956
   (Buena Vista)
   Pencil on paper, 55 x 75.5 cm
   B 9
   Collection of the artist

50 Untitled, 1957
   (Rome)
   Pencil on paper, 22 x 28.5 cm
   B 12
   Collection of the artist

51 Untitled, 1957
   (Rome)
   Pencil on paper, 22 x 28.5 cm
   B 13
   Collection of the artist

52 Untitled, 1957
   (Grottaferrata)
   Gouache, crayon and pencil on paper, 70 x 100 cm
   B 15
   Collection of the artist

53 Untitled, 1957
   (Grottaferrata)
   Oil and crayon on cardboard on canvas, 70 x 100 cm
   Margot Müller, Cologne

54 Untitled, 1957
   (Grottaferrata)
   Gouache, crayon and pencil on paper, 68.5 x 98.2 cm
   Collection of the artist

55 Untitled, 1958
   (Rome)
   Crayon and pencil on paper, 70 x 100 cm
   Private collection, Düsseldorf

56 Untitled, 1958
   (Rome)
   Crayon and pencil on paper, 69.8 x 99.6 cm
   B 18
   Private collection

57 Untitled, 1959
   (New York)
   Pencil on paper, 61.2 x 91.8 cm
   B 20
   Private collection

58 Untitled, 1959
   (New York)
   Pencil on paper, 61.5 x 91.8 cm
   B 19
   Private collection

59 Untitled, 1959
   (Sperlonga)
   Gouache and pencil on paper, 70 x 99.7 cm
   Collection of the artist

60 Untitled, 1959
   (Sperlonga)
   Gouache on paper on canvas, 70 x 100 cm
   Collection of Udo and Anette Brandhorst, Cologne

61 Untitled, 1959
   (Sperlonga)
   Collage and crayon on paper, 36.5 x 30 cm
   Collection of the artist

62 Rape of the Sabines, 1960
   (Sant' Angelo)
   Pencil and pen and ink on paper, 50 x 70.3 cm
   Private collection

63 Untitled (Triumph of Galatea), 1961
   (Mykonos and Rome)
   Crayon, pencil and ball-point pen on paper, 35.5 x 33.3 cm
   B 36
   Collection of the artist

64 Untitled (To Lola), 1961
   (Rome)
   Oil, crayon, pencil and ball-point pen on paper, 70.3 x 100 cm
   B 42
   Collection of the artist

65 Untitled (To Lola), 1961
   (Rome)
   Oil, crayon, pencil and ball-point pen on paper, 70.3 x 100 cm
   B 43
   Collection of the artist

66 Birth of Venus, 1962
(Rome)
Tempera, crayon, coloured pencil and pencil on paper,
50 x 70.3 cm
B 45
Private collection

67 Birth of Venus, 1962
(Rome)
Crayon and pencil on paper, 50 x 70 cm
Collection of the artist

68 Venus and Mars, 1962
(Rome)
Tempera, crayon, pencil and ball-point pen on cardboard,
50 x 70.3 cm
B 47
Collection of the artist

69 Untitled, 1962
(Rome)
Distemper, crayon and pencil on paper, 70 x 100 cm
B 44
Collection of the artist

70 Untitled, 1967
(Rome)
Pencil on paper, 70 x 100 cm
Nicola del Roscio, Rome

71 Untitled, 1967
(Rome)
Pencil on paper, 70 x 100 cm
Nicola del Roscio, Rome

72 Untitled, 1969
(Bolsena)
Crayon, pencil, pastel and felt-tip pen on paper,
70.3 x 99.7 cm
B 63
Private collection

73 Untitled, 1969
(Bolsena)
Crayon, pencil, pastel and felt-tip pen on paper, 70 x 99.7 cm
Private collection

74 Untitled, 1968
(Captiva Island, Florida)
Collage and pencil on paper, 94.7 x 45.5 cm
B 57
Collection of the artist

75 Untitled ('White Collage'), 1971
(Rome)
Collage and pencil on cardboard, 91.2 x 69.2 cm
B 85
Private collection

76 Untitled, 1970
(Rome)
Collage, crayon and pencil on paper, 69 x 104 cm
Private collection

77 Untitled (Study for Treatise on the Veil), 1970
(Capri)
Collage, oil, crayon and pencil on paper, 70 x 100 cm
Private collection

78 Untitled, 1968
(New York)
Oil, crayon and gouache on paper, 74 x 102 cm
Private collection

79 Untitled, 1971
(Rome)
Gouache and crayon on paper, 70.3 x 99.7 cm
B 83
Private collection

80 Untitled, 1970
(Capri)
Collage, crayon and pencil on paper, 62.9 x 57 cm
B 72
Private collection

81 Untitled, 1972
(Rome)
Pencil and chalk on paper, 73 x 101.9 cm
Private collection

82 Virgil, 1973
(Rome)
Oil and crayon on paper, 70 x 99.2 cm
L 54
Collection of the artist

83 To Valéry, 1973
(Rome)
Collage, oil and crayon on paper, 76.4 x 55.5 cm
L 67
Private collection

84 To Tatlin, 1974
(Rome)
Collage, oil and crayon on paper, 76.4 x 55.7 cm
L 60
Collection of the artist

85 To Montaigne, 1974
(Rome)
Collage, oil, crayon and pencil on paper, 76.4 x 56 cm
L 65
Collection of the artist

86 Untitled, 1974
(Captiva Island, Florida)
Collage, crayon and pencil on paper, 75 x 106 cm
L 113
Private collection

87 Pan, 1975
(Bassano)
Collage, watercolour and pencil on paper, 154 x 106.2 cm
L 167
Collection of the artist

88 Nike, 1980
(Bassano)
Oil, distemper, tempera, crayon and pencil on paper,
88 x 70.3 cm
Collection of the artist

89 Untitled, 1981
(Bassano)
Distemper and crayon on paper, 88.5 x 70.5 cm
Collection of the artist

90 Silex Scintillans, 1981
(Bassano)
Oil, crayon and pencil on paper.
Three sections: 100 x 70; 150.5 x 135.5; 100 x 70 cm
Private collection

91 Nimphidia, 1982
(Rome)
Oil, crayon and pencil on paper, 100 x 71 cm
Private collection

92 Nimphidia, 1982
(Rome)
Oil, crayon and pencil on paper, 100 x 71 cm
Collection of the artist

93 Anabasis, 1983
(Rome)
Oil, crayon and pencil on paper, 100 x 70 cm
Private collection

94 Proem, 1983
(Rome)
Oil, crayon and pencil on paper, 100 x 70 cm
Private collection

95 Anabasis, 1983
(Rome)
Oil, crayon and pencil on paper, 100 x 70 cm
Graphische Sammlung, Kunsthaus, Zurich

96 Anabasis, 1983
(Rome)
Oil, crayon and pencil on paper, 100 x 70 cm
Private collection

97 Proteus, 1984
(New York)
Oil and crayon on paper, 76 x 56.5 cm
Private collection

98 Proteus, 1984
(Rome)
Oil and crayon on paper, 76 x 56.5 cm
Collection of the artist

99 Untitled, 1986
(Porto Ercole)
Oil, pastel and gouache on paper, 52 x 72 cm
Private collection

100 Untitled, 1986
(Porto Ercole)
Oil, pastel and gouache on paper, 52 x 72 cm
Private collection

*Sculpture*

With the exception of *Cycnus* (no. 108), all sculptures
in bronze and synthetic resin were cast in Rome under the
supervision of Gabriele Stocchi.

101 Untitled, 1955
(New York)
Wood, cloth, string and matt oil-based wallpaint,
56.5 x 14.3 x 13 cm
Krefeld 2
Collection of the artist

102 Untitled, 1959
(Rome)
Painted synthetic resin, 55 x 36 x 26 cm
Cast no. 2/6
Krefeld 4
Private collection

103 Untitled, 1976
(Rome)
Painted synthetic resin. Height 168 cm;
diameter 21.5 cm (bottom) and 16 cm (top)
Cast no. 5/6
Krefeld 6
Private collection

104 Untitled, 1977
(Rome)
Painted synthetic resin, 87 x 79 x 18.5 cm
Cast no. 2/6
Krefeld 8
Private collection

105 Untitled, 1978
(Rome)
Wood and matt oil-based wallpaint, 23.3 x 51.5 x 32.4 cm
Krefeld 9
Collection of the artist

106 Untitled, 1978
(Rome)
Wood and matt oil-based wallpaint, 31 x 44.5 x 24.3 cm
Krefeld 10
Collection of the artist

107 Untitled, 1978
(Rome)
Wood, cloth, wire, nails and matt oil-based wallpaint,
43 x 222.5 x 19.5 cm
Krefeld 13
Collection of the artist

108 Cycnus, 1978
(Rome)
Painted bronze, 41 x 23.5 x 6 cm
Cast no. 4/4
Krefeld 14
Private collection

109 Untitled, 1979
(Bassano)
Painted bronze, 49 x 42 x 22 cm
Cast no. 2/6
Krefeld 19
Private collection

110 Untitled, 1980
   (Rome)
   Painted synthetic resin, 41 x 24 x 46 cm
   Cast no. 5/6
   Krefeld 21
   Private collection

111 Untitled, 1983
   (Rome)
   Painted bronze, 179 x 23 x 41 cm
   Cast no. 1/5
   Private collection

112 Untitled, 1983
   (Bassano)
   Wood and matt oil-based wallpaint, 186 x 160 x 35 cm
   Collection of the artist

113 Untitled, 1983
   (Bassano)
   Painted bronze, 142 x 23 x 41 cm
   Cast no. 1/5
   Private collection

114 Untitled, 1983
   (Bassano)
   Painted bronze, 82 x 56 x 52 cm
   Cast no. 1/1
   Private collection

115 Untitled, 1984
   (Gaeta)
   Painted bronze and wood, 121 x 36 x 56.5 cm.
   Text: 'And we who have always thought of happiness
   climbing,/would feel the emotion that almost startles
   when/happiness falls.'
   Cast no. 2/4
   Private collection

116 Untitled, 1985
   (Bassano)
   Painted bronze, 175 x 27 x 18.5 cm
   Cast no. 1/5
   Private collection

117 Winter's Passage LUXOR, 1985
   (Porto Ercole)
   Painted wood and nails, 54 x 105.7 x 51.6 cm
   Collection of the artist

118 Humul, 1986
   (Gaeta)
   Painted bronze, 63 x 84.7 x 38 cm
   Cast no. 1/1
   Private collection

119 Rotalla, 1986
   (Gaeta)
   Painted wood, 82 x 69 x 79 cm
   Collection of the artist

# Appendix

# List of Exhibitions

Approximate dates, or those of the openings, are given in cases where full details were not available. Where possible, mention is made of any publication which accompanied an exhibition; this information appears in brackets at the end of each entry.

### One-man Shows

1951 New York, Kootz Gallery: *Duet*. Nov.

Chicago, The Seven Stairs Gallery‹: *Twelve Paintings*. 2-30 Nov. (Leaflet, text by Robert Motherwell)

1953 Florence, Galleria d'Arte Contemporanea: *Mostra di Arazzi di Cy Twombly*.

Princeton, The Little Gallery: *Cy Twombly*.

1955 New York, Stable Gallery: *Cy Twombly*. Jan.

1956 New York, Stable Gallery: *Cy Twombly*.

1957 New York, Stable Gallery: *Cy Twombly*. Feb.

1958 Venice, Galleria del Cavallino: *Cy Twombly*. (Cat., text by Palma Bucarelli)

Rome, Galleria La Tartaruga: *Cy Twombly*. 17 May. (Leaflet, text by Palma Bucarelli)

Milan, Galleria d'Arte del Naviglio: *Cy Twombly*. 1-10 Nov. (Leaflet, text by Palma Bucarelli)

1960 Rome, Galleria La Tartaruga: *Cy Twombly*. 26 April. (Invitation)

Milan, Galleria d'Arte del Naviglio: *Cy Twombly*.

New York, Leo Castelli Gallery: *Cy Twombly*. Oct.

1961 Rome, Galleria La Tartaruga: *Cy Twombly*. Jan. (Cat., with 'Cy Twombly e una parafrasi per Cy Twombly' by Emilio Villa)

Milan, Galleria d'Arte del Naviglio: *Cy Twombly*. (Cat., text by Cesare Vivaldi)

Essen, Galerie Zwirner: *Cy Twombly*. (Cat.)

Paris, Galerie J: *Cy Twombly*. 15 Nov. (Cat., with 'Cy Twombly – La Révolution du Signe' by Pierre Restany)

1962 Venice, Galleria del Leone: *Cy Twombly*. 11 June (Invitation)

Brussels, Galerie Aujourd'hui: *Cy Twombly*.

1963 Rome, Galleria La Tartaruga: *Cy Twombly*. 6 March. (Cat., text by Palma Bucarelli, Gillo Dorfles, Franco Marino, Manfred de la Motte, Frank O'Hara, Pierre Restany, Emilio Villa and Cesare Vivaldi)

Cologne, Galerie Änne Abels: *Cy Twombly*. 20 April-15 May. (Cat., text by Manfred de la Motte)

Turin, Galleria Notizie: *Dipinti di Cy Twombly*. 14 May-15 June. (Cat., text by Carla Lonzi)

Cologne, Galerie Zwirner: *Cy Twombly*.

Lausanne, Galerie Bonnier: *Cy Twombly*. (Cat., text by Manfred de la Motte)

Geneva, Galerie D. Benador: *Cy Twombly: Peintures, Dessins*. Dec. (Cat., text by B[enador])

1964 Basle, Galerie Handschin: *Cy Twombly*. 13 March-30 April. (Cat., text by Manfred de la Motte)

New York, Leo Castelli Gallery: *Nine Discourses on Commodus by Cy Twombly*. May

Munich, Galerie Friedrich und Dahlem: *The Artist in a Northern Climate* (paintings) and *Notes from the Tower* (drawings). Nov.-Dec. (Cat., text by Manfred de la Motte)

1965 Turin, Galleria Notizie: *Cy Twombly*.

Rome, Galleria La Tartaruga: *Cy Twombly*.

Krefeld, Museum Haus Lange: *Cy Twombly*. 3 Oct.-21 Nov. (Cat., text by Paul Wember)

Brussels, Palais des Beaux-Arts: *Cy Twombly*. 2-26 Dec. (Cat., text by Paul Wember)

1966 Amsterdam, Stedelijk Museum: *Cy Twombly*. 14 Jan.-27 Feb. (Cat., text by Paul Wember)

New York, Leo Castelli Gallery: *Cy Twombly: Drawings*. March.

Freiburg im Breisgau, Kunstverein: *Cy Twombly*. (Cat., text by Siegfried Bröse)

1967 Rome, Galleria La Tartaruga: *Cy Twombly*.

Turin, Galleria Notizie: *Opere di Cy Twombly*. (Leaflet)

New York, Leo Castelli Gallery: *Cy Twombly*. 7 Oct.

1968 Milwaukee, Milwaukee Art Center: *Cy Twombly: Paintings and Drawings*. 19 Jan.-18 Feb. (Cat., text by Robert Pincus-Witten)

Rome, Galleria La Tartaruga: *Cy Twombly*.

New York, Leo Castelli Gallery: *Cy Twombly: Paintings*. Nov.

Cologne, Galerie Hake: *Cy Twombly: Zeichnungen*. 27 Nov.-14 Dec. (Invitation)

1969 Cologne, Galerie Zwirner: *Cy Twombly*.

Los Angeles, Nicholas Wilder Gallery: *Cy Twombly: Recent Paintings*.

1970 Rome, Galleria La Tartaruga: *Cy Twombly*. 28 Feb. (Invitation)

Frankfurt, Galerie Ursula Lichter: *Cy Twombly*. 27 May-20 June.

Geneva, Galerie Bonnier: *Cy Twombly*. 4-30 June. (Cat.)

Cologne, Galerie Neuendorff: *Cy Twombly: 'Roman Notes'*.

Naples, Modern Art Agency (Lucio Amelio): *Cy Twombly*.

Stockholm, Svensk-Franska Konstgalleriet: *Cy Twombly*.

1971  Turin, Galleria Sperone: *Cy Twombly*. 22 Feb.

Paris, Galerie Yvon Lambert: *Cy Twombly*. 10 June.

Milan, Galleria dell'Ariete: *Cy Twombly*. 7 Oct. (Cat., text by Gillo Dorfles)

Düsseldorf, Galerie Denise René – Hans Mayer: *Cy Twombly. 8 Gouachen aus dem Jahr 1971*. 3 Sept. (Invitation)

Berlin, Galerie Folker Skulima: *Cy Twombly: Acht Gouachen*.

Cologne, Galerie Möllenhoff: *Cy Twombly*.

Naples, Modern Art Agency (Lucio Amelio): *Cy Twombly*.

1972  New York, Leo Castelli Gallery: *Cy Twombly*. 15 Jan.

Milan, Galleria dell'Ariete: *Cy Twombly*.

Toronto, Dunkelman Gallery: *Cy Twombly: Paintings and Works on Paper*.

Dallas, Janie C. Lee Gallery: *Cy Twombly*.

Minneapolis, Locksley-Shea Gallery: *Cy Twombly*.

Naples, Modern Art Agency (Lucio Amelio): *Cy Twombly*.

1973  Turin, Galleria Sperone: *Cy Twombly*. 8-29 Jan.

New York, Visual Arts Gallery, School of Visual Arts: *Drawings by Cy Twombly*. 11 Jan.-6 Feb.

Zurich, Galerie Art in Progress: *Cy Twombly: Bilder, Zeichnungen und Grafiken*. 23 Feb.-22 March. (Cat., text by Heiner Bastian)

Berne, Kunsthalle: *Cy Twombly: Bilder 1953-1972*. 28 April-3 June. (Cat., text by Carlo Huber and Michael Petzet)

Basle, Kunstmuseum: *Cy Twombly: Zeichnungen 1953-1973*. 5 May-24 June. (Cat., text by Heiner Bastian and Franz Meyer)

London, The Mayor Gallery: *Cy Twombly*. 16 May-9 June.

Munich, Städtische Galerie im Lenbachhaus. *Cy Twombly – Bilder und Zeichnungen 1953-1973*. 10 July-12 Aug. (Cat., text by Heiner Bastian, Carlo Huber, Franz Meyer and Michael Petzet)

Bonn, Galerie Klein: *Cy Twombly: Druckgraphik*.

1974  Munich, Galerie Heiner Friedrich: *Cy Twombly – Roman Notes – Gouachen 1970*. 7 March-7 April.

Turin, Gian Enzo Sperone: *Cy Twombly*. 12 March-7 April. (Invitation)

Brussels, Galerie Oppenheim: *Cy Twombly*. 2-27 April.

Paris, Galerie Yvon Lambert: *Cy Twombly*. 18 April-14 May. (Invitation)

Naples, Modern Art Agency (Lucio Amelio): *Cy Twombly: I Portfolio, tecnica mista, collage, disegno: Natural History Part 1, Mushrooms*. 13 Dec.-10 Jan. 1975 (Invitation)

1975  Berlin, Galerie Georg Nothelfer: *Cy Twombly: Graphic Works*. 17 Jan.-27 Feb.

Geneva, Galerie Jacques Benador: *Cy Twombly: Dessins*. Feb. (Invitation)

Naples, Modern Art Agency (Lucio Amelio): *Cy Twombly: Allusions (Bay of Naples)*. 21 Feb.-21 March (Invitation)

Cologne, Galerie Karsten Greve: *Cy Twombly: Bilder und Zeichnungen*. 1 March-15 April. (Cat., text by Heiner Bastian)

Munich, Galerie Art in Progress: *Cy Twombly: Grey Paintings/ Graue Bilder und Gouachen*. 6(7) March-14(15) April. (Cat., text by Heiner Bastian)

Philadelphia, Institute of Contemporary Art, University of Pennsylvania, and San Francisco, San Francisco Museum of Art: *Cy Twombly: Paintings, Drawings, Constructions 1951-1974*. 15 March-27 April/19 May-22 June. (Cat., text by Heiner Bastian and Suzanne Delehanty)

Munich, Galerie des Verlages Schellmann & Klüser: *Cy Twombly: Graphische Zyklen. Four Etchings – 8 Odi di Orazio – Six Lithographs – Roman Notes – Natural History 1*. 2-30 Oct. (Invitation)

1976  Düsseldorf, Galerie Art in Progress: *Cy Twombly: Bilder und Gouachen*. 31 Jan.-4 March.

Hanover, Kestner-Gesellschaft: *Cy Twombly*. 7 May-20 June. (Cat., text by Heiner Bastian and Carl-Albrecht Haenlein)

Paris, Galerie Jacques Bosser: *Cy Twombly: Editions récentes*. 22 June-30 Sept.

Paris, Musée d'Art Moderne de la Ville de Paris: *Cy Twombly: Dessins 1954-1976*. 24 June-6 Sept. (Cat., text by Suzanne Pagé and Marcelin Pleynet)

New York, Leo Castelli Gallery: *Cy Twombly: Watercolors*. 25 Sept.-16 Oct.

Munich, Galerie des Verlages Schellmann & Klüser: *Cy Twombly: Six Latin Writers and Poets. Some Trees of Italy (Neue Mappenwerke)*. 1 Oct.-30 Nov.

Rome, Gian Enzo Sperone: *Cy Twombly*. 23 Nov.-17 Dec. (Invitation)

1977  Karlsruhe, Galerie Haus 11 Beate Nieschlag: *Cy Twombly*. 21 Jan.-5 March. (Invitation)

Paris, Galerie Yvon Lambert: *Cy Twombly. Three Dialogues*. 17 May. (Invitation)

Cologne, Galerie Karsten Greve: *Cy Twombly: Bilder und Zeichnungen*. 20 May-15 July. (Cat. and poster)

New York, Visual Arts Museum, School of Visual Arts: *Cy Twombly: Paintings*.

1978  The Hague, Artline: *Cy Twombly*. 1 Jan.-6 Feb. (Leaflet)

Munich, Galerie Klewan: *Cy Twombly: Bilder, Collagen, Zeichnungen*. 2 March. (Invitation)

New York, Presented by the Lone Star Foundation at Heiner Friedrich Inc.: *Fifty Days at Iliam*. 18 Nov.-20 Jan. 1979. (Press release and invitation)

1979  New York, Whitney Museum of American Art: *Cy Twombly: Paintings and Drawings 1954-1977*. 10 April-10 June. (Cat. and brochure, text by Roland Barthes)

Naples, Galleria Lucio Amelio: *Cy Twombly: 11 sculture*. 25 May. (Invitation)

Lund, Galleriet: *12 lithographier av Cy Twombly*. 29 Sept.-24 Oct. (Invitation and newssheet)

Cologne, Galerie Karsten Greve: *Cy Twombly: Bilder 1957-1968*. 6 Nov.-20 Jan. 1980. (Invitation and poster)

1980  Dallas, University Gallery, School of the Arts, Southern Methodist University: *Cy Twombly: Paintings and Drawings*. 15 Jan.-26. Feb. (Leaflet, text by William B. Jordan)

London, The Mayor Gallery: *Cy Twombly: Paintings and Drawings 1959-1976*. 18 March-19 April. (Invitation)

Seattle, Richard Hines Gallery: *Cy Twombly: Paintings and Drawings 1956-1975*.

Spoleto, Festival of Two Worlds, Palazzo Anciaiani: *Cy Twombly: Disegni 1955-1975*. 26 June-13 July. (Leaflet, text by Italo Tomassoni)

Paris, Galerie Yvon Lambert: *Cy Twombly*. Oct.

Hamburg, Galerie Munro: *Cy Twombly*. 9 Oct. (Invitation)

Milan, Padiglione d'Arte Contemporanea: *Cy Twombly: 50 disegni 1953-1980*. Oct.-Nov. (Cat., text by Zeno Birolli, Gabriella Drudi and Mercedes Garberi)

Madrid, Galeria Heinrich Ehrhardt: *Cy Twombly: Dibujos*. 15 Dec.-Feb. 1981. (Cat., text by Juan Manuel Bonet)

1981 New York, Castelli Graphics: *Cy Twombly: Natural History I and II*.

Krefeld, Museum Haus Lange: *Cy Twombly. Skulpturen. 23 Arbeiten aus den Jahren 1955 bis 1981*. 27 Sept.-15 Nov. (Cat., text by Marianne Stockebrand and Gerhard Storck)

Newport Harbor, California, Newport Harbor Museum; Madison, Wisconsin, Elvehjem Museum of Art; Richmond, Virginia, Virginia Museum of Fine Arts; and Toronto, Art Gallery of Ontario: *Cy Twombly: Works on Paper 1954-1976*. 2 Oct.-29 Nov.; 24 Jan.-18 March 1982; 15 June-18 July 1982; 4 Sept.-17 Oct. 1982. (Cat., text by Susan C. Larsen)

1982 New York, Sperone Westwater Fischer: *Cy Twombly: Recent Works*. April. (Cat.)

Cologne, Galerie Karsten Greve: *Cy Twombly: Neue Arbeiten. Arbeiten auf Papier 1981-1982*. 4 June-July. (Cat., text by Karsten Greve)

London, The Mayor Gallery: *Cy Twombly*. 28 Sept.-6 Nov. (Cat., text by Richard Francis)

Paris, Galerie Yvon Lambert: *Cy Twombly*. 16 Oct.-18 Nov. (Invitation)

Vancouver, The Vancouver Art Gallery: *Cy Twombly: Prints*. 11 Dec.-30 Jan. 1983. (Leaflet, text by Scott Watson)

1983 New York, Stephen Mazoh Gallery: *Cy Twombly*. 19 April-27 May. (Cat., text by Marjorie Welish)

1984 Cologne, Galerie Karsten Greve: *Cy Twombly*. 27 Jan.-25 March. (Cat. and poster)

Naples, Lucio Amelio: *Cy Twombly*. 8 Feb. (Invitation)

London, The Mayor Gallery: *Cy Twombly*.

Bordeaux, CAPC, Musée d'Art Contemporain: *Cy Twombly: Œuvres de 1973-1983*. 19 May-9 Sept. (Cat., text by Jean-Louis Froment and Jacques Henric)

Vienna, Galerie Ulysses: *Cy Twombly*. 24 May.

Baden-Baden, Staatliche Kunsthalle: *Cy Twombly: Malerei, Arbeiten auf Papier, 1955-1983*. 23 Sept.-1 Nov. (Cat., text by Katharina Schmidt)

New York, Hirschl & Adler Modern: *Cy Twombly: Paintings and Drawings: 1952-1984*. 11 Oct.-3 Nov. (Cat.)

1985 Cologne, Galerie Karsten Greve: *Cy Twombly*. 15 Nov.-8 Jan. 1986. (Invitation)

Zurich, Galerie & Edition Stähli: *Cy Twombly: Drawings and Prints*. 23 Nov.-18 Jan. 1986. (Invitation)

1986 Rome, Studio Arco d'Alibert: *Segno e Scrittura. Cy Twombly*. Feb. (Cat., text by Totti Scialoja)

New York, Larry Gagosian Gallery: *Cy Twombly. Drawings, Collages and Paintings on Paper 1955-1985*. 22 Feb.-5 April. (Invitation)

New York, Hirschl & Adler Modern: *Cy Twombly*. 12 April-7 May. (Cat., text by Roberta Smith)

Cologne, Galerie Karsten Greve: *Cy Twombly*. 29 Aug.-16. Oct. and 2 Sept.-6 Nov. (Invitation)

## Group Exhibitions

1953 *Rauschenberg: Paintings and Sculpture / Cy Twombly: Paintings and Drawings*. New York, Stable Gallery, 15 Sept.-3 Oct.

1958 *International Festival*. Osaka, Japan.

1959 *Novelli, Perilli, Scarpitta, Twombly, Vandercam*. Rome, Galleria La Tartaruga, 2 July. (Leaflet)

Brussels, Galerie Aujourd'hui.

*Gouaches*. Rome, Galleria La Tartaruga, Dec. (Invitation)

1960 *Gastone Novelli – Achille Perilli – Cy Twombly*. Stuttgart, Galerie Müller, 28 May-end of June. (Leaflet, text by Heinz Spielmann)

*Opere di piccolo formato*. Rome, Galleria La Tartaruga, 3 Dec. (Invitation)

*Rauschenberg, Twombly: Zwei amerikanische Maler*. Düsseldorf, Galerie 22. (Cat., text by Jean Pierre Wilhelm)

1961 *Premio Lissone*. Milan.

*Kounellis, Schifano, Twombly*. Rome, Galleria La Tartaruga, Nov. (Invitation)

*Kounellis, Rauschenberg, Schifano, Tinguely, Twombly*. Rome, Galleria La Tartaruga, Dec. (Invitation)

1962 *Sculture di Nevelson. Dipinti di Twombly*. Turin, Galleria Notizie, 19 Jan.-Feb. (Cat., text by Carla Lonzi and Pierre Restany)

*Premio Marzotto*. Milan.

Turin, Galleria Incontri.

*Neun europäische Künstler*. Berlin, Haus am Waldsee.

1963 *13 Pittori a Roma*. Rome, Galleria La Tartaruga, 9 Feb. (Cat.)

*Schrift und Bild*. Amsterdam, Stedelijk Museum, 3 May-10 June, and Baden-Baden, Staatliche Kunsthalle, 14 June-4 Aug. (Cat.)

*Salon de Mai*. Paris.

New York, Leo Castelli Gallery.

*Aspetti dell' Arte contemporanea*. Aquila.

London, Robert Fraser Gallery.

1964 *XXXII Biennale*. Venice.

Rome, Galleria Nazionale d'Arte Moderna.

*American Drawings*. New York, The Solomon
R. Guggenheim Museum, Sept.-Oct. (Cat., text by Lawrence
Alloway)

*Kunst des 20. Jahrhunderts in Kölner Privatbesitz*. Cologne,
Kunstverein, Hahnentorburg, 12 Nov.-20 Dec. (Cat.)

1966 *Novelli – Perilli – Scialoja – Twombly*. Bologna, Galleria de'
foscherari, 2-22 April. (Invitation)

*Recent American Painting*. New York, The Museum of Modern
Art.

1967 *Annual Exhibition of Contemporary American Painting and Sculpture*. New York, Whitney Museum of American Art.

*Kunst des 20. Jahrhunderts aus rheinisch-westfälischem Privatbesitz*.
Düsseldorf, Städtische Kunsthalle and Kunstverein für die
Rheinlande und Westfalen, 30 April-18 June. (Cat.)

*Ten Years*. New York, Leo Castelli Gallery.

*Contemporary Drawings*. New York, New York University,
Loeb Student Center.

1968 *L'Art Vivant 1965-1968*. Saint Paul, Fondation Maeght,
13 April-30 June. (Cat.)

*Sammlung Hahn. Zeitgenössische Kunst*. Cologne, Wallraf-
Richartz-Museum, 3 May-7 July. (Cat., text by Paul Wember)

*Querschnitt durch die moderne Kunst von Paul Klee bis Roy Lichtenstein*. Ulm, Museum, Studio f, 7 July-1 Sept. (Cat.)

*Sammlung 1968 Karl Ströher*. Hamburg, Kunstverein, 24 Aug.-
6 Oct. (Cat.)

*Italienische Kunst des 20. Jahrhunderts*. Cologne, Kunsthalle, and
Bochum, Museum.

*Highlights of the Art Season*. Richfield, Larry Aldrich Museum.

1969 *Kunst der sechziger Jahre. Sammlung Ludwig*. Cologne, Wallraf-
Richartz-Museum, 28 Feb. (Cat.)

*Annual Exhibition of Contemporary American Painting and
Sculpture*. New York, Whitney Museum of American Art.

*Sammlung Karl Ströher*. Berlin, Neue Nationalgalerie, 1 March-
14 April; Düsseldorf, Städtische Kunsthalle, 25 April-
17 June; and Berne, Kunsthalle, 12 July-28 Sept. (Cat.)

*Painting and Sculpture Today*. Minneapolis, Minneapolis Museum of Art; and New York, Finch College Museum of Art.

Turin, Galleria Notizie.

*American Art of the Sixties in Toronto Private Collections*.
Toronto, York University.

*Art on Paper*. Greensboro, University of North Carolina,
Weatherspoon Art Gallery.

*Contemporary Drawing Show*. Fort Worth, Fort Worth Art
Center.

*heutige kunst*. Aachen, Suermondt-Museum, May-Aug.
(Cat., text by Klaus Honnef)

1970 *Klischee + Antiklischee. Bildformen der Gegenwart*. Aachen,
Neue Galerie im Alten Kurhaus, 28 Feb.-18 April. (Cat.)

*Sammlung Etzold*. Cologne, Kölnischer Kunstverein, 19 May-
19 July. (Cat.)

*Annual Exhibition of Contemporary American Painting and
Sculpture*. New York, Whitney Museum of American Art.

*The Drawings Society's New York Regional Drawing Exhibition*.
New York, Cooper-Hewitt Museum.

*Dipinti/Paintings (Johns, Pistoletto, Warhol, Twombly, Arman,
Dine, Stella)*. Turin, Galleria Sperone, 1 Oct.

*Due decenni di eventi artistici in Italia: 1950/1970*. Prato, Palazzo
Pretorio, Oct.-Nov. (Cat.)

1971 *Rosc' 71*. Dublin, Royal Dublin Society.

*The Drawn Line in Painting*. Boston, Parker Street Gallery.

*The Structure of Color*. New York, Whitney Museum of American Art.

*Fünf Sammler – Kunst unserer Zeit*. Wuppertal, Von der Heydt-
Museum, 5 June-11 July. (Cat.)

1972 New York, Storm King Art Center.

*Dealer's Choice*. La Jolla, La Jolla Museum of Contemporary
Art.

*New York Painters: Cy Twombly, David Diao*. Amherst, Mass.,
Main Gallery of the Harold E. Johnson Library Center,
Hampshire College.

*Actualité d'un bilan*. Paris, Galerie Yvon Lambert, Oct. (Cat.,
text by Michel Claura)

*Collectors Items*. New York, Ronald Feldman Gallery, 14 Oct.

1973 *Biennial Exhibition of Contemporary American Painting and
Sculpture*. New York, Whitney Museum of American Art.

*Mit Kunst leben – Zeitgenossen*. Stuttgart, Württembergischer
Kunstverein, 19 April-27 May (Cat.)

*Beuys, Hockney, Twombly*. Cologne, Galerie Rolf Möllenhoff
und Karsten Greve, 3-24 May.

*American Drawings 1963-1973*. New York, Whitney Museum
of American Art, 25 May-22 July. (Cat.)

*Arts du 20ᵉ siècle. Collections genevoises*. Geneva, Musée Rath,
28 June-23 Sept. (Cat.)

*Ein grosses Jahrzehnt amerikanischer Kunst. Sammlung Ludwig,
Köln/Aachen*. Lucerne, Kunstmuseum, 15 July-16 Sept. (Cat.)

*Prospect 73 – Maler*. Düsseldorf, Städtische Kunsthalle,
28 Sept.-7 Oct. (Cat. – slide)

*A Selection of Fifty Works from the Collection of Robert C. Scull*.
New York, Sotheby Parke Bernet Inc., 18 Oct. (Cat.)

*Pittori Americani in Europa*. Prato, Palazzo Pretorio.

*New York Collection for Stockholm*. Stockholm, Moderna
Museet, 27 Oct.-9 Dec. (Cat.)

*New York's Finest*. Washington, Max Protetch Gallery.

*Contemporanea – Incontri internazionali d'Arte*. Rome, Parcheggio di Villa Borghese, Nov.-Feb. 1974. (Cat., text by Michel
Claura, Mario Diacono, Alessandro Mendini, Achille Bonito
Oliva and others)

1974 *Strata. Paintings, drawings and prints by Ellsworth Kelly, Brice
Marden, Agnes Martin, Robert Ryman and Cy Twombly*. London,
Royal College of Art Galleries, 14 Jan.-1 Feb. (Cat.)

*Art conceptuel et hyperréaliste. Collection Ludwig*. Paris, Musée
d'Art Moderne de la Ville de Paris, 31 Jan.-10 March. (Cat.)

*Eight Artists*. Corpus Christi, Art Museum of South Texas, 8 Feb.-24 March. (Cat., text by Roberta Bernstein and David Whithney)

*Works by Robert Rauschenberg and Cy Twombly*. New York, Leo Castelli Gallery, 4-25 May. (Invitation)

*America on Paper*. Basle, Galerie Beyeler, May-June. (Leaflet)

*American Works on Paper 1944 to 1974*. New York, William Zierler Inc., 2-30 Nov. (Cat.)

*Joseph Beuys and Cy Twombly: Lithographien und collagierte, zum Teil weitergezeichnete Lithos 1974*. Hamburg, Galerie Gunter Sachs, 22 Nov.-19 Dec.

*In den unzähligen Bildern des Lebens … Surrealität – Bildrealität 1924-1974*. Düsseldorf, Städtische Kunsthalle, 8 Dec.-2 Feb. 1975, and Baden-Baden, Staatliche Kunsthalle, 13 Feb.-20 April 1975. (Cat.)

1975 *Geschriebene Malerei: Carlo Alfano, Annalies Klophaus, Roman Opalka, Dieter Rühmann, Cy Twombly, Ben Vautier*. Karlsruhe, Badischer Kunstverein, 18 Jan.-2 March. (Cat., text by Cy Twombly, Heiner Bastian, Franz Meyer, Manfred de la Motte and Michael Schwarz)

*Enquête sur une Année d'Activité Plastique*. Paris, Galerie la Pochade, 6 Feb.-5 March. (Leaflet)

*Dessins contemporains*. Rennes, Maison de la Culture, 1 March-5 April.

*Funkties van Tekenen – Functions of Drawing (Collection Visser)*. Otterlo, Rijksmuseum Kröller-Müller, 25 May-4 Aug. (Cat.)

*Proposta*. Rome, Galleria Navona, June. (Leaflet)

*Von Pop zum Konzept – Kunst unserer Zeit in belgischen Privatsammlungen*. Aachen, Neue Galerie Sammlung Ludwig, 8 Oct.-9 Nov. (Cat.)

*Jim Dine, Roy Lichtenstein, Morris Louis, Michelangelo Pistoletto, Robert Rauschenberg, Mario Schifano, Frank Stella, Cy Twombly, Andy Warhol*. Turin, Rome, New York and Sperone. (Cat.)

*Revisione I – Lavori su carta*. Milan, Galleria dell'Ariete.

*Cy Twombly/John Chamberlain*. Minneapolis, Locksley-Shea Gallery.

*drawing/transparence – disegno/trasparenza*. Rome, Canaviello Studio d'Arte, Dec.-Feb. 1976. (Cat.)

1976 *19 Americani – 1970-1975*. Milan, USIS Centro culturale, 8-30 Jan. (Cat.)

*Drawing Now*. New York, The Museum of Modern Art, 21 Jan.-20 Feb. (Cat., text by Bernice Rose)

*Twentieth-Century American Drawing: Three Avant-Garde Generations*. New York, The Solomon R. Guggenheim Museum, Jan.-Feb. (Cat.)

*Line*. New York, School of Visual Arts, 26 Jan.-18 Feb., and Philadelphia, Philadelphia College of Art, 5 March-9 April.

*L'Esperienza Moderna*. Rome, Galleria Marlborough, 5 Feb.-27 March.

*Zeichnen/Bezeichnen – Functions of Drawing (Collection Visser)*. Basle, Kunstmuseum, 7 Feb.-4 April. (Cat., text by Franz Meyer)

*Manzoni, Kounellis, Schifano, Twombly*. Rome, Galleria Marino, March.

*Handzeichnungen*. Munich, Galerien an der Maximilianstrasse, April. (Cat.)

*Amerikanische Zeichner des 20. Jahrhunderts – Drei Generationen von der Armory Show bis heute*. Baden-Baden, Staatliche Kunsthalle, 27 May-11 July. (Cat.)

*Three decades of American Art selected by the Whitney Museum*. Tokyo, Seibu Museum of Art, 18 June-20 July. (Cat.)

*Schriftbild*. Vienna, Galerie nächst St. Stephan, June.

*8e Festival International de la Peinture*. Cagnes sur Mer, Château-Musée, 3 July-30 Sept. (Cat.)

*American Master Drawings and Watercolors*. Minneapolis, The Minneapolis Institute of Arts, 1 Sept.-26 Oct.

*Amerikanische Kunst heute*, Berlin, Galerie Georg Nothelfer, 4 Sept.-31 Oct.

*New York in Europa – Amerikanische Kunst aus Europäischen Sammlungen*. Berlin, Nationalgalerie, 4 Sept.-7 Nov. (Cat.)

*A propos d'Automatisme*. Paris, Chapelle de l'Hôpital de la Salpêtrière, 4-17 Oct.

*Zeichnung heute – Drawing Now*. Zurich, Kunsthaus, 10 Oct.-14 Nov.; Baden-Baden, Staatliche Kunsthalle, 25 Nov.-16 Jan. 1977; and Vienna, Graphische Sammlung Albertina, 20 Jan.-28 Feb. 1977. (Cat., text by Erika Gysling-Billeter and Bernice Rose)

*Prospect/Retrospect – Europa 1946-1976*. Düsseldorf, Städtische Kunsthalle, 20-31 Oct. (Cat.)

*USA + USA (Kelly, Johns, Lichtenstein, Oldenburg, Rauschenberg, Rosenquist, Twombly, Warhol)*. London, The Mayor Gallery, 10 Nov.-17 Dec. (Invitation)

*1900-1976. 100 Dessins du Musée de Grenoble*. Grenoble, Maison de la Culture, Nov.-Dec. (Cat.)

*American Master Drawings and Watercolors*. New York, Whitney Museum of American Art, 23 Nov.-23 Jan. 1977.

*Modern Grafika Pécs, 1976*. Pécs, Modern Magyar Képtàr, Janos Pannonius Múzeum. (Cat.)

1977 *Jubilation. American Art during the Reign of Elizabeth II*. Cambridge, The Fitzwilliam Museum, 10 May-18 June. (Cat.)

*Handzeichnungen*. Kassel, documenta 6, 14 June-14 Oct. (Cat., text by Wieland Schmied)

*1960-1977. Arte in Italia: Dall'opera al coinvolgimento/L'opera: Simboli e immagini/La linea analitica*. Turin, Galleria Civica d'Arte Moderna, May-Sept. (Cat., text by Renato Barilli, Antonio del Guercio and Filiberto Menna)

Munich, Galerie Klewan, 3 Nov. (Invitation)

1978 *Artenatura*. Venice, XXXVIII Biennale, Giardini di Castello, 2 July-15 Oct. (Cat., text by Antonio del Guercio and others)

1979 *Groups II*. London, Waddington Galleries, 9 Jan.-3 Feb. (Cat.)

*Artemisia*. Paris, Yvon Lambert. (Book, text by Roland Barthes and others).

*La Materia dell' Arte. Tra Surrealismo e pittura americana*. Bari, Basle, Rome and Paris, Agenzia d'Arte Moderna, 29 March. (Cat., text by Achille Bonito Oliva)

1980 *Joseph Beuys, Yves Klein, Jannis Kounellis, Piero Manzoni, Arnulf Rainer, Francesco Lo Savio, Cy Twombly. Wendepunkt. Kunst in Europa um 1960*. Krefeld, Museum Haus Lange, 11 May-6 July. (Cat., text by Gerhard Storck)

*L'arte negli anni settanta*. Venice, xxxix Biennale, Giardini di Castello, 1 June-30 Sept. (Cat., text by Michael Compton, Martin Kunz, Achille Bonito Oliva and Harald Szeemann)

*Beuys – Rainer – Twombly*. Munich, Galerie Klewan, 2 Oct. (Invitation)

1981  *A New Spirit in Painting*. London, Royal Academy of Arts, 15 Jan.-18 March. (Cat., text by Christos M. Joachimides, Norman Rosenthal and Nicholas Serota)

*Westkunst. Zeitgenössische Kunst seit 1939*. Cologne, Rheinhallen, Messegelände, 30 May-16 Aug. (Cat., text by Laszlo Glozer)

*Espace peint, espace traversé/La Danse*. Toulon, Musée de Toulon, 16 July-6 Sept. (Invitation)

*Amerikanische Kunst 1930-1980*. Munich, Haus der Kunst.

Cologne, Galerie Rudolf Zwirner, 6 Nov. (Invitation)

1982  *Joseph Beuys, Robert Rauschenberg, Cy Twombly, Andy Warhol: Sammlung Marx*. Berlin, Nationalgalerie, 2 March-12 April, and Mönchengladbach, Städtisches Museum Abteiberg, 6 May-30 Sept. (Cat., text by Heiner Bastian)

*Avanguardia Transavanguardia*. Rome, Mura Aureliana, May-July. (Cat., text by Achille Bonito Oliva)

*documenta 7*. Kassel, Museum Fridericianum, 19 June-28 Sept. (Cat., text by Germano Celant and Rudi Fuchs)

*USA (Dine, Johns, Lichtenstein, Rosenquist, Twombly, Warhol)*. London, The Mayor Gallery, 6 July-6 Aug. (Invitation)

*Zeitgeist – Internationale Kunstausstellung*. Berlin, Martin-Gropius-Bau, 15 Oct.-16 Jan. 1983. (Cat., text by Christos M. Joachimides, Norman Rosenthal and others)

*A Private Vision: Contemporary Art from the Graham Gund Collection*. Boston, Museum of Fine Arts. (Cat.)

New York, Acquavella Galleries, 21 Oct.-24 Nov. (Cat.)

Düsseldorf, Galerie Maier-Hahn, Nov.-Dec. (Leaflet)

*Balthus & Twombly*. Zurich, Thomas Ammann Fine Art. (Cat.)

*Chia, Cucchi, Lichtenstein, Twombly*. New York, Sperone Westwater Fischer, 4 Dec.-4 Jan. 1983. (Invitation)

1983  *Amerikanische Graphik*. Düsseldorf, Kunsthandel Wolfgang Wittrock.

*Nicola de Maria, Barry Flanagan, Jannis Kounellis, Detlef Orlopp, Norbert Prangenberg, Cy Twombly*. Cologne, Galerie Karsten Greve, 4 Feb.-10 March.

*Neue Zeichnungen aus dem Kunstmuseum Basel – Eine repräsentative Auswahl der neuen Ankäufe*. Tübingen, Kunsthalle.

*to the happy few – Bücher, Bilder, Objekte aus der Sammlung Reiner Speck*. Krefeld, Museum Haus Lange and Museum Haus Esters, 15 May-10 July. (Cat., text by Reiner Speck and Gerhard Storck)

*Informale in Italia – Mostra dedicata a Francesco Arcangeli*. Bologna, Galleria d'Arte Moderna.

1984  *Philip Guston, Robert Mangold, Brice Marden, Malcolm Morley, Cy Twombly*. New York, Galerie Maeght Lelong, 22 March-27 April. (Invitation)

*The Meditative Surface*. Chicago, The Renaissance Society at the University of Chicago, 1 April-16 May. (Cat., text by Carter Ratcliff)

*Une collection imaginaire*. Winterthur, Kunstmuseum.

*La rime et la raison. Les collections Ménil (Houston, New York)*. Paris, Galeries Nationales du Grand Palais, 17 April-30 July. (Cat., text by Walter Hopps)

*Heckel, Mueller, Kirchner, Dubuffet, Beuys, Twombly, Kounellis, Anzinger, Tannert: Zum Mythos der Ursprünglichkeit*. Leverkusen, Städtisches Museum, Schloss Morsbroich, 6 May-7 June. (Cat., text by Elisabeth Bott and Rolf Wedewer)

*Légendes. A Michel Montaigne*. Bordeaux, CAPC Musée d'Art Contemporain, 19 May-9 Sept. (Cat., text by Jean-Louis Froment, Philippe Sollers and others)

*Skulptur im 20. Jahrhundert*. Basle, Merian-Park, 3 June-30 Sept. (Cat., text by Werner Jehle)

*Terrae Motus*. Ercolano, Villa Campolieto, 6 July-31 Dec. (Cat., text by Michele Bonuomo)

*Nineteenth and Twentieth Century Works of Art*. New York, Stephen Mazoh & Co., Inc., autumn. (Cat.)

*La grande parade*. Amsterdam, Stedelijk Museum, 15 Dec.-15 April 1985. (Cat., text by Roland Barthes)

*Ouverture. Arte contemporanea*. Turin, Castello di Rivoli, 18 Dec. (Cat., text by Rudi Fuchs)

1985  *Twentieth Century Works of Art*. New York, Stephen Mazoh & Co. Inc., spring and autumn. (Cats.)

*Cinquante ans de dessins américains 1930-1980*. Paris, Ecole nationale supérieure des Beaux-Arts, 3 May-13 July. (Cat.)

*Italia aperta. Nicola de Maria, Sol LeWitt, Hidetoshi Nagasawa, Giulio Paolini, Cy Twombly, Emilio Vedova*. Madrid, Fundacion Caja de Pensiones, 29 May-31 July. (Cat., text by Roland Barthes, Heiner Bastian, Gillo Dorfles and Aurora García)

*Museum? Museum! Museum. Kunst von heute in Hamburger Privatsammlungen*. Hamburg, Museum für 40 Tage, 3 June-15 July. (Cat.)

*Art of Our Time*. London, The Saatchi Collection, summer. (Cat., text by Robert Rosenblum)

*Von Twombly bis Clemente. Ausgewählte Werke einer Privatsammlung*. Basle, Kunsthalle, 14 July-16 Sept. (Cat., text by Roman Hollenstein)

*Dreissig Jahre durch die Kunst. Museum Haus Lange 1955-1985*. Krefeld, Museum Haus Lange and Museum Haus Esters, 15 Sept.-1 Dec. (Cat., vol. I with text by Manfred de la Motte, Gerhard Storck and Paul Wember, vol. II. with text by Gerhard Storck)

*Clemente. Kiefer. Twombly. Unique Books*. London, Anthony d'Offay, 5 Sept.-2 Oct. (Invitation)

*Works on Paper*. Zurich, Turske & Turske, 23 Nov-7 Dec. (Invitation)

*Spuren, Skulpturen und Monumente ihrer präzisen Reise*. Zurich, Kunsthaus, 29 Nov.-23 Feb. 1986. (Cat., text by Roland Barthes and Harald Szeemann)

1986  *Gesto astrazione informale*. Rome, Il Segno, Feb. (Cat.)

*In Tandem. The Painter-Sculptor in the Twentieth Century*. London, Whitechapel Art Gallery, 27 March-25 May. (Cat., text by Lynne Cooke and Nicholas Serota)

*De Sculptura*. Vienna, Wiener Festwochen im Messepalast, 16 May-20 July. (Cat., text by Roland Barthes and Harald Szeemann)

*Origins Originality + Beyond.* Sydney, The Biennale of Sydney, 16 May-6 July. (Cat., text by Nick Waterlow)

*Cy Twombly. Christopher Wilmarth. Joe Zucker.* New York, Hirschl & Adler Modern, 21 May-27 June. (Cat.)

*Referencias: un encuentro artistico en el tiempo: Georg Baselitz, Eduardo Chillida, Antonio Saura, Richard Serra, Antoni Tapies, Cy Twombly.* Madrid, Centro de Arte Reina Sofia, 26 May-15 Sept. (Cat., text by Francisco Calvo Serraller)

*Hommage à Beuys.* Munich, Städtische Galerie im Lenbachhaus, 16 July-2 Nov. (Cat.)

*Europa/Amerika. Die Geschichte einer künstlerischen Faszination seit 1940.* Cologne, Museum Ludwig, 6 Sept.-30 Nov. (Cat., text by Siegfried Gohr and Rafael Jablonka)

*Die Landschaft.* Bielefeld, Kunsthalle, 13 April-22 June; Baden-Baden, Staatliche Kunsthalle, 12 July-14 Sept.; and Kaiserslautern, Pfalzgalerie, 19 Oct.-30 Nov. (Cat.)

*Intuitive Line.* New York, Hirschl & Adler Modern, 6 Dec.-3 Jan. 1987.

*Arbeiten auf Papier.* Hamburg, Galerie Ascan Crone, 4 Dec.-17 Jan. 1987.

*SkulpturSein.* Düsseldorf, Städtische Kunsthalle, 12 Dec.-1 Feb. 1987. (Cat., text by Roland Barthes, Jürgen Harten and Harald Szeemann)

1987   *About Sculpture. Carl Andre, Joseph Beuys, Gilbert & George, Willem de Kooning, Jannis Kounellis, Richard Long, Mario Merz, Bruce Naumann, David Smith, Cy Twombly, Boyd Webb, Lawrence Weiner.* London, Anthony d'Offay Gallery, 28 Jan.-5 March.

# Selected Bibliography

## Publications by the Artist

Spenser, Edmund, *The Shepheardes Calendar, illustrated by Cy Twombly,* London: Anthony d'Offay, 1985
Twombly, Cy, 'Signs', *Esperienza Moderna* 2 (1957).
  –, *Fifty Days at Iliam: A Painting in Ten Parts,* Frankfurt, Berlin and Vienna: Verlag Ullstein GmbH, Propyläen Verlag, 1979.

## Monographs

Barthes, Roland, *Cy Twombly,* Berlin: Merve Verlag, 1983.
Bastian, Heiner, *Cy Twombly. Zeichnungen 1953-1973,* Frankfurt, Berlin and Vienna: Verlag Ullstein GmbH, Propyläen Verlag, 1973.
  –, *Cy Twombly. Bilder – Paintings 1952-1976,* Frankfurt, Berlin and Vienna: Verlag Ullstein GmbH, Propyläen Verlag, 1978.
  –, *Cy Twombly. Das Graphische Werk 1953-1984. A Catalogue Raisonné of the Printed Graphic Work,* Munich and New York: Edition Schellmann, 1984.
Heyden, Thomas, 'Zu Sehen und zu Lesen. Anmerkungen zum Verständnis des Geschriebenen bei Cy Twombly', M. A. thesis, University of Bonn, 1986.
Lambert, Yvon, and Barthes, Roland, *Cy Twombly. Catalogue raisonné des œuvres sur papier,* vol. VI: 1973-1976, Milan: Edizione Multhipla, 1979.
Olsen, Charles, 'Cy Twombly', Black Mountain College, 1951 (typescript).

## Other Literature

Apuleio, Vito, 'A Spoleto gli incontri 80. Un po' di cultura locale non guasta', *Il Messaggero* (6 July 1980).
Arghir, Anca, 'Cy Twombly – Galerie Karsten Greve', *Das Kunstwerk* 37,3 (June 1984).
Ashton, Dore, 'Cy Twombly at Stable Gallery', *Art Digest* (15 Sept. 1953), p. 20.
  –, 'The Artist as Dissenter', *Studio International* (April 1966), pp. 164-65.
Baker, Kenneth, 'Cy Twombly at Castelli Gallery', *Artforum* (April 1972), pp. 81-82.
Ballerine, Julia, 'Cy Twombly at Sperone Westwater Fischer', *Art in Ameria* 70,10 (Nov. 1982).
Barthes, Roland, 'Sagesse de l'art', *Peinture Cahiers Théoriques* 16/17 (May 1983), pp. 7-32.
  –, *The Responsability of Forms,* New York: Hill and Wang, 1985.
Bastian, Heiner, *Joseph Beuys, Robert Rauschenberg, Cy Twombly, Andy Warhol: Sammlung Marx,* Munich: Prestel Verlag, 1979.
Bernstein, Roberta, 'Cy Twombly – Recent Prints', *The Print Collector's Newsletter* 11,6 (1976), p. 149ff.
Billeter, Erika, *Leben mit Zeitgenossen. Die Sammlung der Emanuel Hoffmann-Stiftung,* Basle, 1980.

Binder-Hagelstange, Ursula, 'Geschrieben in Zeit und Raum', *Frankfurter Allgemeine Zeitung* (29 May 1973).

Blistène, Bernard, 'Cy Twombly – Fifty Days at Iliam', *Flash Art* (March-April 1979).

Bode, Ursula, 'Private Zeichen auf der Flucht in weisse Wände', *Hannoversche Allgemeine Zeitung* (2 June 1976).

Bowles, Jerry, 'Cy Twombly at Castelli Gallery', *Arts Magazine* (Dec. 1968), p. 59.

Calas, Nicolas and Elena, in *Icons and Images of the Sixties,* New York, 1971, p. 134.

Calvesi, Maurizio, 'Cy Twombly', *L'Espresso* (Feb. 1968).

Campbell, Lawrence, 'Rauschenberg and Twombly', *Art News* (Sept. 1953), p. 50.

–, 'Cy Twombly at Castelli Gallery', *Art News* (May 1964).

–, 'Cy Twombly at Castelli Gallery', *Art News* (Dec. 1967), p. 55 ff.

Cane, Louis, 'Cy Twombly – tentation de la peinture', *Art Press* 46 (March 1981), p. 9 (rpt. in *Peinture Cahiers Théoriques* 16/17 [May 1983], p. 165 ff.).

Catoir, Barbara, 'Cy Twombly – Galerie Karsten Greve', *Frankfurter Allgemeine Zeitung* (23 March 1984).

Celant, Germano, *Das Bild einer Geschichte 1956/1976. Die Sammlung Panza di Biumo. Die Geschichte eines Bildes. Action Painting, Newdada, Pop art, Minimal art, Conceptual Environmental art,* Milan: Electa International, 1980.

Chabanne, Thierry, 'Une écriture pilsionnelle', *Info Artitudes* 9 (June 1976), p. 9.

Crehan, Hubert, 'Cy Twombly at Stable Gallery', *ArtDigest* (Jan. 1955).

Collin, Jane, 'Cy Twombly at Castelli Gallery', *Arts Magazine* (April 1966), p. 54.

Crimp, Douglas, 'New York Letter', *Art International* (March-April 1973), pp. 57-58.

Crispolti, Enrico, 'Les Nouveaux Romains', *Aujourd'hui* (Jan. 1965), p. 68.

De Ak, Edith, 'Robert Rauschenberg and Cy Twombly at Castelli downtown', *Art in America* 62, 4 (July-Aug. 1974), p. 86.

De la Motte, Manfred, 'Cy Twombly', *Blätter und Bilder* 12 (Jan.-Feb. 1961), pp. 62-71.

–, 'Cy Twombly', *Quadrum* 16 (1964), pp. 35-46.

–, 'Cy Twombly', *Art International* (June 1965), p. 32.

–, 'Cy Twombly', *Kunstforum* 4/5 (1973), pp. 112-23.

Delehanty, Suzanne, 'The Alchemy of Mind and Hand', *Art International* (Feb. 1976).

Dienst, Rolf Gunter, 'Ausstellungen in Düsseldorf und Köln', *Das Kunstwerk* (May 1963).

Dorfles, Gillo, 'Le Immagini Scritte di Cy Twombly/Written Images of Cy Twombly', *Metro* 6 (1962), pp. 62-71.

–, 'Un senso di grandiosità', *Arte Milano* 1,1 (May 1972).

–, *Il divenire della critica,* Turin: Einaudi, 1976, p. 84.

Dunoyer, Jean-Marie, 'Mouvements perpétuels', *Le Monde* (9 Sept. 1976).

Engelbert, Arthur, *Die Linie in der Zeichnung. Klee – Pollock – Twombly,* Essen: Verlag Die blaue Eule, 1985.

Fahlström, Öyvind, 'Malare i Rom', *Konstrevy* 4 (1957), p. 140.

Feldstein, Ron, 'Cy Twombly's Eloquent Voice', *Arts Magazine* (Jan. 1985), p. 90 ff.

Fischer, Alfred M., 'Cy Twombly', in *Handbuch Museum Ludwig. Kunst des 20. Jahrhunderts,* Cologne: Museum Ludwig, 1979.

Fitzsimmons, James, 'Cy Twombly at Kootz Gallery', *Art Digest* (Dec. 1951), p. 20.

–, 'Art', *Art and Architecture* (Oct. 1953).

Franzke, Andreas, *Skulpturen und Objekte von Malern des 20. Jahrhunderts,* Cologne: DuMont, 1982, pp. 193-94.

Garcia, Aurora, 'Cy Twombly', *Batik* 59 (Jan.-Feb. 1981), pp. 35-36.

Geelhaar, Christian, 'Schweiz', *Pantheon* 31, 3 (July 1973), pp. 325-36, and 31,4 (Oct. 1973), pp. 449-50.

Gendel, Milton, 'Recent Exhibitions in Milan', *Art News* (Jan. 1959), p. 52.

Georges-Lemaire, Gérard, 'Cy Twombly, le scribbeur', *Opus International* 74 (1979), pp. 48-49.

Glozer, Laszlo, 'Auffinden von Gestalt: Zeichen für Zeichen', *Süddeutsche Zeitung* (21 June 1973).

–, 'Die psychische Zuständigkeit der Zeichnung', *Süddeutsche Zeitung* (3 April 1974).

Gorsen, Peter, 'Sexualität im Spiegel der modernen bildenden Kunst', in *Sexualforschung, Stichwort und Bild,* Hamburg: Verlag für Kulturforschung, 1963, p. 476.

Hayes, Richard, 'Cy Twombly at Castelli Gallery', *Art News* (Dec. 1960), p. 15.

Herrera, Hayden, 'Cy Twombly, Robert Rauschenberg at Castelli Gallery', *Art News* 73,8 (Oct. 1974), p. 110.

Hess, Thomas B., 'Cy Twombly at Castelli Gallery', *New York Magazine* (18 Oct. 1976).

Hoppe-Sailer, Richard, 'Aphrodite Anadyomene. Zur Konstitution von Mythos bei Cy Twombly', in *Modernität und Tradition. Festschrift für Max Imdahl zum 60. Geburtstag,* Munich: Wilhelm Fink Verlag, 1985, p. 125 ff.

Judd, Donald, 'Cy Twombly at Castelli Gallery', *Arts Magazine* (May 1964) (rpt. in *Donald Judd, Complete Writings 1959-1975,* Halifax, 1975, p. 128).

Kaepplin, Olivier, 'Cy Twombly', *Flash Art* 110 (Jan. 1983), pp. 72-73.

Kahmen, Volker, in *Erotik in der Kunst. Aspekte zur Kunst der Gegenwart,* Tübingen: Wasmuth, 1971, p. 160.

Kerber, Bernhard, *Amerikanische Kunst seit 1945,* Stuttgart: Reclam, 1971, p. 92 ff.

Kingsley, April, 'Cy Twombly at Castelli Gallery', *Art News* (March 1972).

Kipphoff, Petra, 'Cy Twombly – Galerie Karsten Greve', *Die Zeit* (24 Feb. 1984).

Kozloff, Max, 'Cy Twombly at Castelli Gallery', *Artforum* (Dec. 1967).

Kultermann, Udo, *Neue Formen des Bildes,* Tübingen: Wasmuth, 1969.

Lampert, Catherine, 'Exhibition at Mayor Gallery', *Studio International* (July 1973), p. 44.

Last, Martin, 'Cy Twombly at Castelli Gallery', *Art News* (Jan. 1969), p. 64.

Le Bot, Marc, 'Twombly-Aristée les abeilles et les entrelacs', *La Quinzaine Littéraire* (19 July 1976).

Legrand, Francine C., 'Peinture et Ecriture', *Quadrum* 13 (1963), pp. 5-48.

–, 'Propos sur les signes et l'œuvre ouverte', in *Depuis 1945. L'art de notre temps,* vol. 1, Brussels: La Connaissance, 1969, p. 126.

Leonhard, Kurt, 'Stuttgarter Kunstbrief', *Das Kunstwerk* (July 1960), p. 78.

Mahlow, Dietrich, 'Die Schrift in der Malerei von Heute. Warum geschriebene Bilder?', *Das Kunstwerk* (April 1963), pp. 2-24.

Martin, Henry, 'Milan and Turin', *Art International* (Dec. 1971), p. 77.

Mayer, Rosemary, 'Cy Twombly at the School of Visual Arts Gallery', *Arts Magazine* (March 1973), p. 73.

Mellow, James R., 'New York Letter', *Art International* (Feb. 1969), p. 46.

Metken, Sigrid, 'Die Bildpostkarte in der Kunst – Sublimierung bei Cy Twombly', *Das Kunstwerk* (Jan. 1974), pp. 3-42.

Meyer, Franz, *Rede zur Eröffnung der Ausstellung Cy Twombly in der Kunsthalle Bern* (28 April 1973) (typescript)

Monteil, Annemarie, 'Auf der Suche nach einer Sprache', *National-zeitung,* Basle (17 May 1973).

Morris, Linda, 'Strata: Paintings, Drawings and Prints by Ellsworth Kelly, Brice Marden, Agnes Martin, Robert Ryman and Cy Twombly at the Royal College of Art Galleries, London', *Studio International* 963 (Feb. 1974), p. 92.

Myers, John Bernard, 'Marks: Cy Twombly', *Artforum* 20, 8 (April 1982), pp. 50-57.

Nemser, Cindy, 'Cy Twombly at Castelli Gallery', *Arts Magazine* (Dec. 1967), p. 55.

Ohff, Heinz, 'Geschriebene Bilder', *Tagesspiegel,* Berlin (27 Jan. 1974).

O'Hara, Frank, 'Cy Twombly at Stable Gallery', *Art News* (Jan. 1955) p. 46.

Oliva, Achille Bonito, 'Cy: una stanza a volo radente', *Carta Bianca* (May 1968) (rpt. in Achille Bonito Oliva, *Passo dello Strabismo. Sulle arti,* Milan: Feltrinelli, 1978, p. 108 ff.)

–, *Transavantgarde international,* Milan: Politi, 1982, p. 7.

Patton, Phil, 'Cy Twombly at Castelli Gallery', *Artforum* (Dec. 1976).

Peillex, Georges, 'Cy Twombly: Galerie Bonnier', *Werk* 3 (1964).

'Perniola – Barthes – Twombly', *Kalejdoskop.* 6/1983 (1984).

Pfeiffer, Günter, '"Roman Notes" in Köln', *Das Kunstwerk* (June 1970), p. 73.

Pincus-Witten, Robert, 'Cy Twombly', *Artforum* 12, 8 (April 1974), p. 60 ff.

–, 'Cy Twombly at the Institute of Contemporary Art, Philadelphia', *Artforum* 13, 10 (June-Aug. 1975), p. 63.

Platt, Selma, and Robbins, Daniel, 'The Albert Pilavan Collection: Twentieth-Century American Art', *Bulletin of Rhode Island School of Design* (May 1969), pp. 42–45.

Pleynet, Marcelin, 'La peinture par l'oreille (Cy Twombly)', *Tel Quel* 67 (autumn 1976), p. 10 ff. (rpt. in *Art et Littérature,* Paris: Seuil, 1977, pp. 304-23).

Pohlen, Annelie, 'Cy Twombly – Museum Haus Lange, Krefeld', *Flash Art* 105 (1981).

–, 'Cy Twombly – Galerie Karsten Greve', *Kunstforum* 70, 2 (March 1984).

–, 'Cy Twombly', *Artforum* 20, 8 (April 1984), p. 87.

Poinsot, Jean-Marc, 'Cy Twombly – Quand la ligne n'est plus un tracé', *Art Press* 11 (May 1974), p. 8 ff.

Ponente, Nello, *L'arte moderna; il dopoguerra; dal naturalismo astratto all'informale,* Milan: Fabbri, 1967, pp. 268, 272, 278.

Prigent, Christian, 'Twombly ou l'entre-deux', *NDLR* 2 (autumn 1976), p. 34 ff.

Ratcliff, Carter, 'New York Letter', *Art International* (March 1972).

–, 'Whitney Annual', *Artforum* (April 1972), p. 28 ff.

Read, Prudence B., 'Cy Twombly at Kootz Gallery', *Art News* (Dec. 1951), p. 48.

Restany, Pierre, *Lyrisme et Abstraction,* Milan: Apollinaire, 1960, p. 94.

Reuther, Hanno, 'Cy Twombly', *Das Kunstwerk* (Feb. 1969), pp. 79-80.

Robertson, Bryan, 'Cy Twombly at Castelli', *Art in America* (March-April 1972), pp. 199-200.

Roditi, Edouard, 'The Widening Gap', *Arts Magazine* (Jan. 1962), p. 55.

Ruhrberg, Karl, *Kunst im 20. Jahrhundert. Das Museum Ludwig, Köln,* Stuttgart: Klett-Cotta, 1986.

Russell, John, 'Three Striking Current Shows', *The New York Times* (7 Jan. 1979).

–, 'Art: Twombly Writ on Whitney Walls', *The New York Times* (13 April 1979).

Sawin, Martica, 'Cy Twombly at Stable Gallery', *Arts Magazine* (Feb. 1957), p. 57.

–, 'Cy Twombly at Castelli Gallery', *Arts Magazine* (Nov. 1960), p. 59.

Scarpetta, Guy, 'Cy Twombly – Sismographies', *Art Press* 46 (March 1981), p. 6 ff.

Schloss, Edith, 'Art in Rome', *International New York Tribune* (1 March 1973).

Sheffield, Margareth, 'Cy Twombly: Major Changes in Space, Idea, Line', *Artforum* 17, 9 (May 1979), pp. 40-45.

Smith, Roberta, 'Drawing Now (And Then)', *Artforum* (April 1976), p. 52 ff.

–, 'Cy Twombly at Stephen Mazoh Gallery', *Village Voice* (1983).

Snoddy, Stephen, 'Cy Twombly', *Circa* 7 (Nov.-Dec. 1982), p. 20.

Speck, Reiner, 'Leonardo zwischen Beuys und Twombly', *Deutsches Ärzteblatt* (Nov. 1974), p. 3280.

Strasser, Catherine, 'Cy Twombly. Galerie Yvon Lambert', *Art Press* 65 (Dec. 1982), p. 50.

Thwaites, John Anthony, 'Vom Urkasten zur Urknolle', *Deutsche Zeitung* (3 May 1963) (rpt. in idem, *Der doppelte Maßstab. Kunstkritik 1955-1966,* Frankfurt: Egoist-Bibliothek/Adam Seide, 1967, pp. 207-08).

Trini, Tomaso, 'Mostre – Cy Twombly alla Galleria dell'Ariete', *Domus* (Nov. 1971), p. 51.

'Cy Twombly', *Catalogo 1,* Rome: Galleria La Tartaruga (15 June 1964).

'Cy Twombly', *Catalogo 3,* Rome: Galleria La Tartaruga (10 June 1966).

'Cy Twombly', in *Art of Our Time: The Saatchi Collection,* vol. II, London: Lund Humphries, and New York: Rizzoli, 1984.

'Cy Twombly', in *Von Twombly bis Clemente. Ausgewählte Werke einer Privatsammlung,* Basle: Kunsthalle, 1985.

Valsecchi, Marco, 'Cy Twombly', *Il Giorno* (Nov. 1958).

Vivaldi, Cesare, 'Cy Twombly: Between Irony and Lyricism', *La Tartaruga* (Feb. 1961).

Volpi, Marisa, 'Intervista con Cy Twombly', *Avanti!* (23 Nov. 1961).

–, 'Twombly alla Galleria La Tartaruga', *Avanti!* (22 March 1963).

–, *Arte dopo il 1945 U.S.A.,* Rocca San Casciano: Cappelli, 1969, pp. 70-71, 151, 208.

Welish, Marjorie, 'A Discourse on Twombly', *Art in America* 5 (Sept. 1979), p. 80 ff.

Wember, Paul, 'Mein schönster Ankauf – Cy Twombly', *Neue Rheinzeitung* (13 Nov. 1964).

–, 'Twombly', *Centroarte* 4 (March 1967), pp. 38-39.

William, Mac, 'A Union of Sex and Sea. Cy Twombly', *Vanguard* 5 (June-July 1979), p. 11 ff.

Wolmer, Denise, 'Cy Twombly at Castelli Gallery', *Arts Magazine* (March 1972).

Zacharias, Thomas, *Blick der Moderne. Einführung in ihre Kunst,* Munich and Zurich: Schnell & Steiner, 1984.

'Zwischen Kunst und Leben – Cy Twombly im Basler Kunstmuseum', *Basler Volksblatt* (11 May 1973).

*Photographic Acknowledgments*

Thomas Ammann Fine Art, Zurich (4, 10, 16)

Archiv Heiner Bastian / Jochen Littkemann / Ektachrom-Duplikate
Fachlabor für Farbfotografie Jacobs & Schulz, Berlin (3, 5, 11,
15, 17, 21, 28, 32, 39)

Walter Dräyer, Zurich (2, 7, 9, 20, 27, 31, 34-36, 40, 41, 43, 47-54,
57-60, 62-69, 70-77, 79-82, 84-86, 88-92, 97, 98, 101, 104, 107,
111-119)

Galerie Karsten Greve, Cologne (6, 8, 12, 22, 23, 29, 30, 33, 42, 78,
94, 108)

Photocolor Hinz, Allschwil (1)

Hirshhorn Museum and Sculpture Garden, Smithsonian
Institution, Washington (17)

Krefelder Kunstmuseum, Krefeld (102, 103, 105, 106, 109, 110)

Jochen Littkemann, Berlin / Galerie Karsten Greve, Cologne
(14, 24, 25, 39)

Friedrich Rosenstiel / Galerie Karsten Greve, Cologne (37, 38, 42,
56, 58, 93, 99, 100)

Saatchi Collection, London (18)

Dorothy Zeidler, New York (44-46)